Film Actors

Volume 2

CLARK GABLE

Documentary study

Part 1

ISBN-13 : 978-1514182437
ISBN-10 : 1514182432

Copyright©2012-2014 Iacob Adrian
All Rights Reserved.

Notice

This documentary study use historic, archived documents.

Because of this, some pages may look blurry or low quality.

Still are included in this book because they have

high value from critical, documentary, historical,

informative and journalistic point of view .

Dtp and visual art

Iacob Adrian

Copyright©2012-2014 Iacob Adrian
All Rights Reserved.

Author statement

The actors and actresses are the the bricks .

The cast and crew are the plaster .

They stand on the foundation created by producers and writers and directors .

All these people creates the great palace of the art of film .

Iacob Adrian - 2013

This little Book conveys the greetings of

..

to

..

———————————————

Christmas Comes to Hollywood

by JERRY LANE

SNOW PELTED HIM, lashed by wind from the mountain tops. This was no movie snow of whitened corn flakes. This was the real stuff —and Clark Gable grinned.

Some undefinable impulse had urged him to drive up to Lake Arrowhead this evening. He'd headed for it alone as soon as he left the studio. Kind of help along the Holiday spirit to see a touch of old-fashioned winter. Deep black woods outlined against untrampled fields of white. He would drive back the next day and be home in time for Christmas Eve celebration.

A sudden clap of thunder reverberated overhead. Maybe, thought Clark, he was getting into more than he'd bargained for. Only sixty-five miles from Hollywood—and here he was facing a blizzard that would have done justice to the Montana prairies.

Montana. Funny he hadn't thought in years of the old gang there with whom he'd played in stock. What had become of them all? Jim and Steve and Wheezy? A great fellow, Wheezy. Used to be a comedian one night and a "heavy" the next. He had an ugly scar from chin to cheek—souvenir of an early football game. Clark remembered how red it had got that Christmas when Wheezy's girl had invited them for dinner.

Then, abruptly, all reminiscences were shut out by the storm. It was whipped to a fury now. Tall trees bent before it. Clark stepped on the accelerator. No need turning back. Better to push on to the village that bordered one end of the lake. He was straining forward. The edge of the twisting road was RTY—ning blurred and familiar sign ibyna were blotted out completely. Richa.

Another hour a' e knew that somehow he'd taken the wrong turn. He was going towards the other end of the lake where there were only a few forsaken cabins. Drifts loomed up large in front of him. Trackless ground. The car veered swiftly and stopped. Clark found himself lunging in the direction of a distant cabin from which a faint light flickered. There seemed to be need of haste. He had to hurry.

● The answer was given him the minute he opened that door. A big fellow lay on a makeshift couch, his face wet with the dreadful sweat of pain. There was a scar from his chin to his cheek.

"God—*Wheezy!*"

"Why—Bill. Is that you? And the big fellow lapsed into unconsciousness.

His leg was broken. It lay in a

Some strange whim took Clark Gable into the mountains one Yuletide and as a result he was able to aid an old pal in dire distress

manner that made "Bill" Gable catch his breath.

There was a sound at the fireplace where a thin flame burned futilely against the stinging cold. A small boy looked wearily up at him. And Clark knew why he had had to get to Lake Arrowhead that night.

"Peace on earth." The chimes from the Normandy tower rang out the hour of midnight as he entered the village. It had been seven miles of struggle over frozen snow to get there but fortunately a doctor was staying at the lodge. They drove back in a sleigh.

At three in the morning Wheezy's leg was set and he was asleep. So was his son — curled up in Clark's coat. A huge fire crackled in the grate, spreading warmth, shutting out the shadows. And Clark, with a deep new content, threw himself down beside the youngster.

Later in the day he drove them both back to Beverly Hills. The doctor rode with them. He'd strapped Wheezy's leg up and propped him with pillows. Gradually the big fellow's story came out. Not an unusual one. He hadn't worked for a year and in desperation had accepted a friend's offer of the Arrowhead cabin to live in for the winter.

"I thought there might be something to do with all the people coming up for the winter sports, but

A certain Christmas would have been a mighty dismal affair for Una Merkel had it not been for the thoughtfulness of Helen Hayes

How Clark Gable and other stars have captured the true meaning and spirit of Christmas

yesterday morning I—slipped. The kid here is only five. You couldn't send him out alone after help."

No you couldn't. But you could keep him up an extra hour that Christmas Eve to see old man Santa Claus arrive at the Gable home. He came in with a sack full of toys and shoes and the like that, strangely enough, were just the right size for a five-year-old. And there was a happy

Marlene Dietrich and little daughter Maria follow quaint old German customs and find great happiness in welcoming Kris Kringle

grin on his face that wasn't part of the make-up!

Wheezy is working steadily in the studios now. They say he is a real "find" among character actors.

● Let's roll back the clock a minute to Christmas, 1924.

Here in Hollywood it was one of those rainy days when everything seems to sag—including the spirit. Along the boulevard the decorations had a wilted look. The once-gay wreaths dripped cheerlessly and the Salvation Army lassies huddled under umbrellas on the street corners as they pleaded with a wet world to "keep the pot a-boiling."

Scurrying by under the awnings was a small young person intent on playing a game.

"Listen here, Janet Gaynor," she'd say to herself. "Think of your figure! If you're going to be a star you'd

better watch out! And besides, you really don't like turkey dinners anyway."

But that didn't keep her from pressing her nose against bright restaurant windows and reading the menus on display. "Um—I think I'll have some white meat, please, and lots of gravy and mashed potatoes and mince pie. . . ." She drew her coat closer and moved on.

It was bad enough being a complete stranger in the town, let alone being without money. And why did it have to rain, too? Janet's courage was ebbing with every fresh gust of wind. Mother and Jonesy had given up a lot to bring her here. Would she ever make good—a timid, funny kind of girl like her?

The tears were pretty close as she stood on the corner waiting for the traffic signals to change. A great limousine slid to a silent stop in

Robert Young lost his job because of his sympathy for the down-and-outer but the tables were turned in a strange way another Christmas

front of her. Inside, swathed in furs and toying with a corsage of gardenias, was a famous star. To Janet, she seemed the most glamorous person on earth as their eyes met for an instant. Something in the young girl's face must have stirred the older woman. She leaned forward suddenly and tossed her corsage through the window with a gay "Merry Christmas!" as her car started off.

Janet caught the flowers, buried her radiant little face in them. Then she began to run. She ran all the way back to mother and Jonesy. The gardenias were a symbol to her, a token that Fate was on the job and everything was going to be all right. It doesn't take much sometimes to shift the balance!

That very week she was given her first bit of extra work and her sensational climb had begun.

The tables have a way of turning swiftly and without warning in Filmtown. That famous star of the silent pictures became an Unknown to the talkies. Just another forgotten face—until Janet happened to catch sight of her in a crowd scene one day. Now she's well on the road up again. And on Christmas each year a mysterious florist's box arrives at the home of the former celebrity. Inside is a sheaf of fragrant gardenias.

● Holiday season. Holiday verve. Brilliant red holly berries dancing in the windows beside lighted candles. In Marlene Dietrich's home you see them in every front window. And sometimes an eager little face looking at them—Maria, her young daughter. Always, on the twenty-fourth of December, they go to the woods and gather branches for "Kris Kringle." Just the two of them tramping

Please turn to page fifty-four

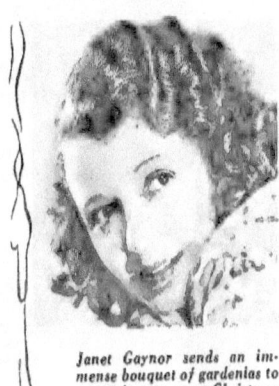

Janet Gaynor sends an immense bouquet of gardenias to a certain star every Christmas and in her motive lies an appealing story

Christmas Comes to Hollywood

excitedly through thick underbrush on the California hills.

"Look, mother, will *he* like this one?"

"He's sure to, darling! That's beautiful!" Not "la" Dietrich of the dramatic personality speaking. This is Marlene in her biggest rôle—that of mother.

All her life she has followed the quaint old German customs for Christmas, even to setting out a feast presumably for "Kris." Secretly, she herself makes the jolly animal cookies to surprise Maria.

You'll find them everywhere in Hollywood, these gay trees ablaze with colored lights. They decorate every studio set as well.

And The Tales That go the rounds—memories of other Christmases. Una Merkel, chin propped in hands, tells of the time the cast of *Coquette* had to leave New York on December twenty-fourth to open the next day in Chicago. It was pretty bleak, with every click of the rails carrying her further from her family. No one had much to say. You could cut the gloom with a knife until Helen Hayes, the star of the show, insisted that they all come to her hotel suite the next morning. Wonderingly, they went—to be greeted by Santa Claus in person!

Helen had wired ahead for flowers, tree, presents, elaborate dinner and all. And made that Christmas a highlight in place of a heartache.

It takes so little, really, to do that. There was Robert Young's strange experience, for instance.

When Bob was getting his training at the Pasadena Community Playhouse he used to work days for an insurance company. That was in 1929. But even so, Bob came across a good many destitute families because it was his duty to give them formal notice of foreclosure on their house by the company. Did he hate it? He did! Most of the time he'd go back to his boss and report a diptheria sign on the door or give some other excuse for not presenting the notice. And the boss found it out. He was a blustering fellow and the terms he used to discharge Bob were not exactly choice.

Then the "big, bad wolf" came along and blew away his own job, and his house and his car.

It was December twenty-third when the front office at the studio called Bob to say there was a man to see him. "He says he must see you. Matter of life and death." And so it proved. Bob opened the door to discover his old boss sitting there. There was no apologetic look in his eyes; they were too desperate. "It's my wife, Bob. She's sick. There's no food. . . ." The same story Bob had heard so often when he went to deliver those notices! Coming from *this* man!

The two of them went out together—to a grocery store. And before they left Bob had telephoned a doctor.

He visited his one-time boss on Christmas morning. There was a "notice" in his hand. Made up to look exactly like those others, only this one said that until the man found a job there would be money in the bank upon which he could draw weekly.

And so—*Christmas comes to Hollywood.*

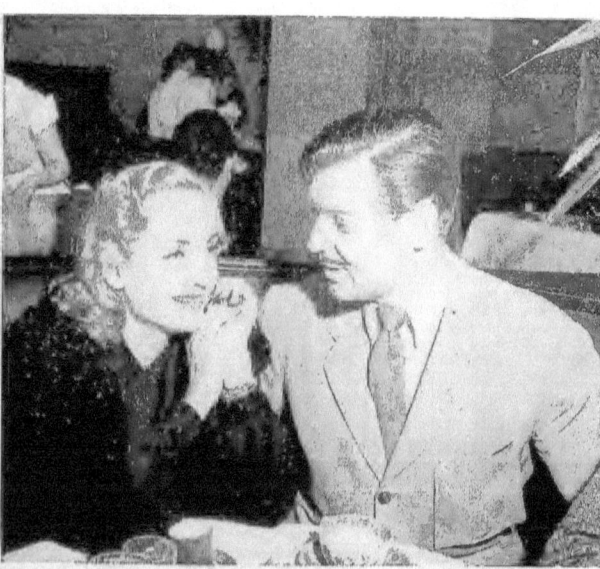

Dining out at the Brown Derby are Ma and Pa Gable. Clark has just completed *Comrade X* with Hedy Lamarr. Carole is working on RKO's *Mr. and Mrs. Smith*

AN OPEN LETTER TO CLARK GABLE

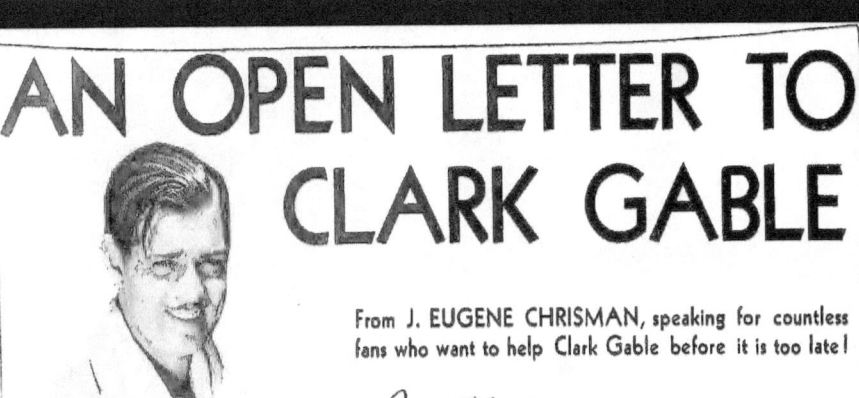

From J. EUGENE CHRISMAN, speaking for countless fans who want to help Clark Gable before it is too late!

Dear Clark,

WHEN LAURETTE TAYLOR became a big star in *Peg O' My Heart*, she noticed that the audiences were not as friendly to her as they had been at the beginning of the play. She complained to her husband, Hartley Manners, author of the play, and asked him why.

"Because," said Manners, "when you were on the way up you asked your audience to love you. Now that you are on top, you demand that they do."

I am not saying that applies to you, Clark, but people *are* talking. They are saying that success has gone to your head. They can't say that you are slipping for the way the fans mobbed you in New York proves that they still think you're a swell guy. The thing they don't like is that you are no longer the love-'em-and-leave-'em Clark Gable of old. They are beginning to believe that you have traded your leather jacket and turtle-neck sweaters for a dress suit. They are saying that you are getting fed up with it all and that your work lacks the fire and virility that it formerly had. Perhaps it isn't true, Clark, but even if it isn't, it doesn't do you any good for such talk to get around. That's why I'm writing you this letter.

● I've known you a long time. I've written a lot of stories about you and you've always been a good egg. You've come a long way, Clark, since you played the heavy in *The Painted Desert*. It's been fun watching you grow. I hate to see you spoil it all now by giving up mulligan stew for caviar. Perhaps even you don't realize how far you have come. Your former wife, Josephine Dillon, once said of you,

"When I first knew Clark Gable all he needed was a toothpick behind his ear, a gold tooth and a celluloid collar to make him a perfect hick."

I don't believe you were that bad, Clark, for by that time the rubber factory, the oil fields and the lumber camps were behind you. You had been places and seen things. But no matter how uncouth you may have been, there has always been a fine streak underneath. Josephine Dillon did a lot for you and so did Lillian Albertson, who got you your rôle in *The Last Mile*.

Women have been kind to you, Clark, but unlike Lou Tellegen, you haven't written a book about it. Your innate fineness has prevented that. You hate a man who kisses and tells. Your dead stepmother, about whom I once wrote a story, must have been a splendid woman for I have heard you discuss women many times and no woman who ever came in contact with you has ever been spoken of with disrespect.

Because there is something of the eternal boy in you, women have been the milestones on the road to your success. There was Treela your first sweetheart in Hopedale, Norma the blonde girl in Akron. There was Elsa when you were in stock in Mississippi and

Please turn to page forty-five

NEXT MONTH READ CLARK GABLE'S REPLY

An Open Letter to Clark Gable

Alice, also in the South. Then, when you were in Silverton, Oregon, there was Franz. It was she, you remember, who first told you that your English must be improved and who bought books and helped you study them. There was Josephine Dillon, Ruth Collier and now your wife, Rea.

Every One Of These women gave you something, Clark, but it was a fair exchange for you gave them something in return. They gave you affection, help and inspiration and you in turn gave them of your youth, your virility and your strength. Then came your success on the screen and you were able to give to millions of women what you had before been able to give to but a few.

I wonder if you know or realize what you gave these women, Clark? I wonder if you know how many thousands of starved lives and lonely hearts you entered into, a White Knight in shining armor to lighten the tedium of their days and nights? I wonder if you realize your responsibility to these women and what you would do to them if you took their dreams away?

But the thing that you gave them was Clark Gable. It is Clark Gable they want, the vigorous, virile, menacing Clark Gable of *A Free Soul*. You reached your utmost height as *Ace Wilfong* in that picture. That's the man they want to see again and not a pale imitation in a full dress suit. They don't want the polished gentleman you threaten to become. Your formula was a dangerous toughness under a thin veneer of self-education and a hastily acquired culture. That Clark Gable thrilled women because every woman was sure that she would not be safe for one minute with him alone.

You threaten to become a gentleman, Clark, and it won't do. *Ace Wilfong* has learned to wear tails and dawdle a teacup on his knee. He has bought a string of race horses, developed a bulge in his mental waistline and learned to use the right fork.

Your old swagger seems gone. Your smile which was bitter, sullen and hard, now comes too easily. The chip has been removed from your shoulder. The devil-may-care twinkle in your eye which made women want to take you in their arms, even while they shuddered in apprehension of your brutality, is gone. Your own wife has admitted that you are getting tired of it all.

You are a great personality, not a great actor. I think you would be the first to admit that. You may resent this letter but I don't think you will. I speak for millions of your fans when I say that I have seen Hollywood spoil too many careers and that I don't want it to spoil yours. Give your fans more he-man rôles. Tear off that boiled shirt and let us see the hair on your chest again.

Always your friend,

J. Eugene Chrisman

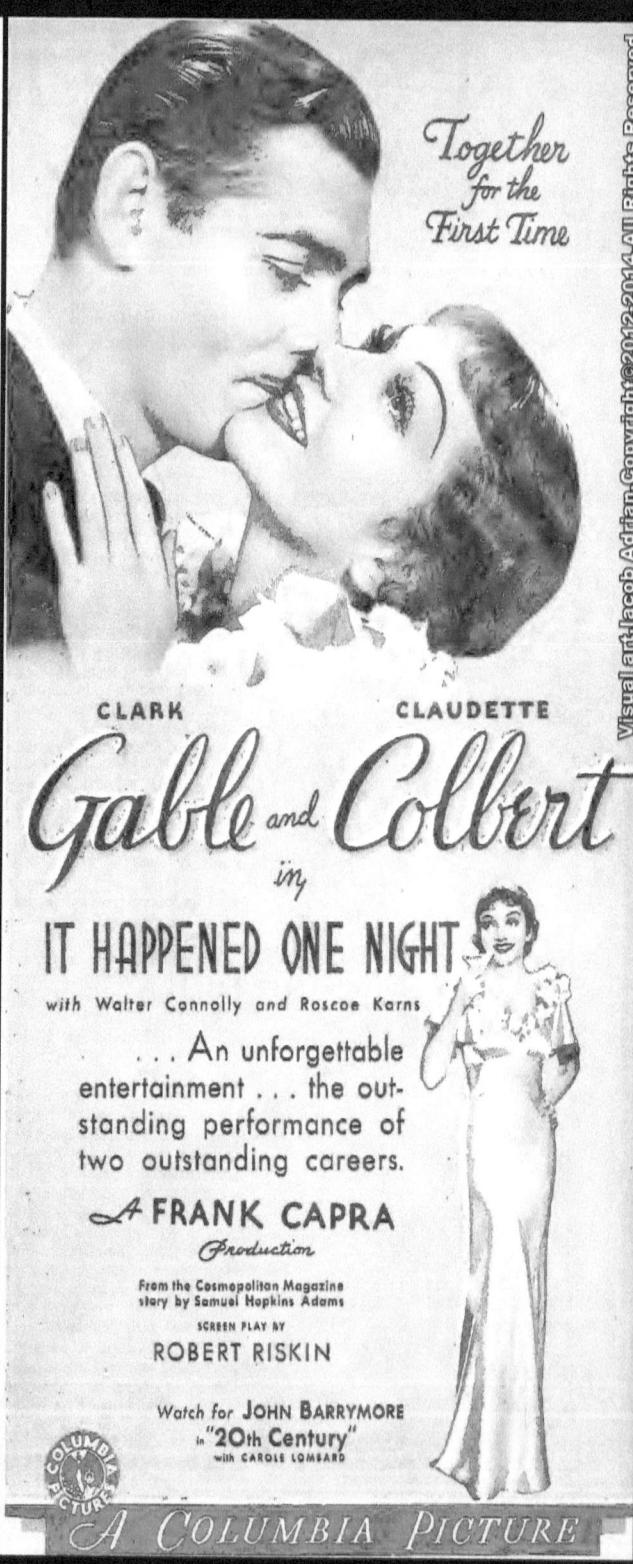

CLARK GABLE AND CLAUDETTE COLBERT *in "It Happened One Night," a Columbia Picture*

Gable did not kiss

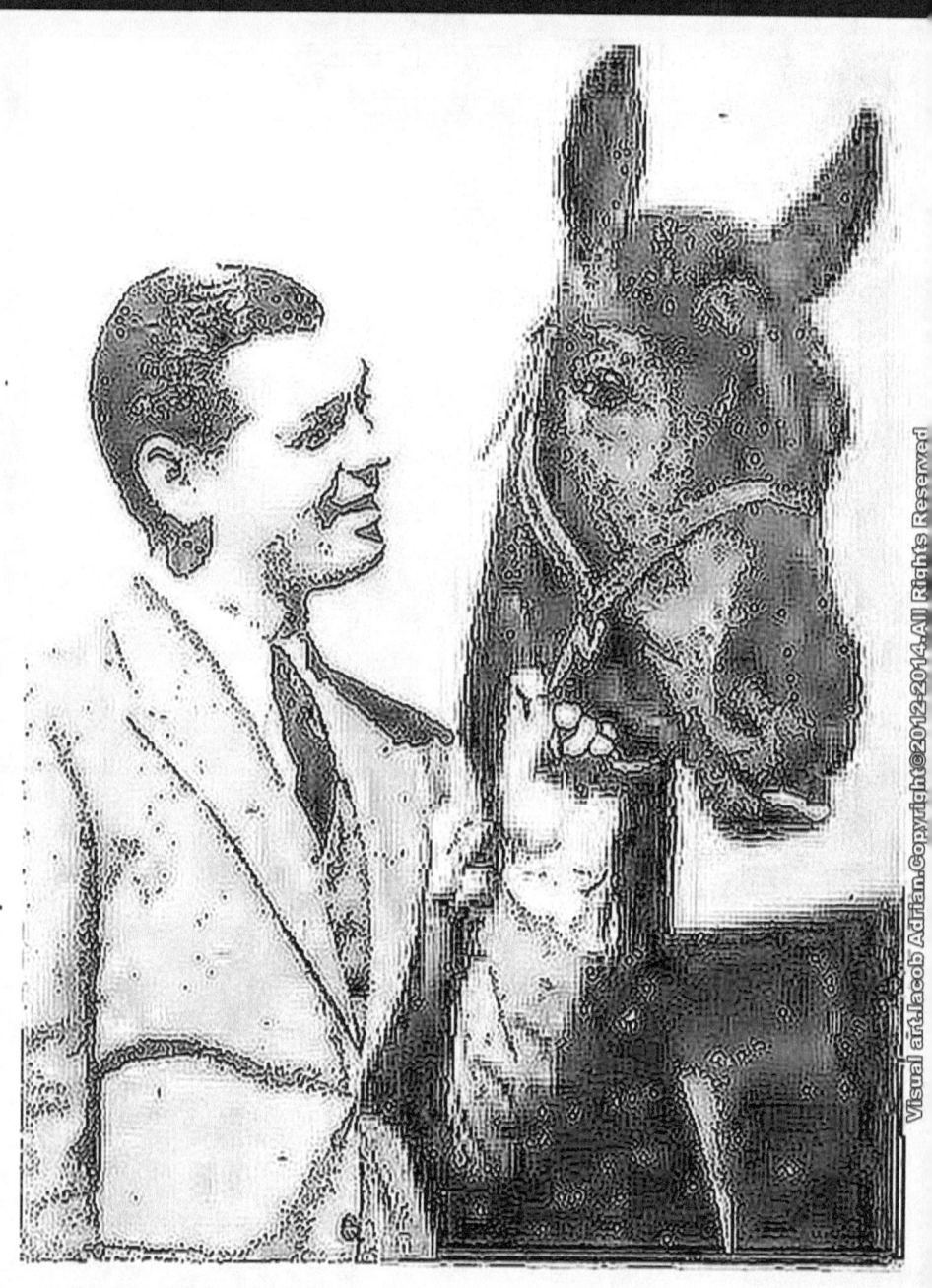

Clark Gable's two-year-old filly, "Beverly Hills," shows great promise of becoming a heavy winner on the race tracks

AN OPEN LETTER TO JOAN CRAWFORD

J. Eugene Chrisman speaks to Joan on behalf of her fans! Watch for her reply next month

CLARK GABLE REPLIES TO J. EUGENE CHRISMAN

To tell him he'll always be a mulligan eater at heart!

Dear Joan,

THE GOSSIPS are at it again. They just won't let you alone, will they Joan? I remember when they were calling you a hey-hey girl whose only ambition was to make whoopee and win dancing cups. They said that you couldn't go far on the screen because you were too flighty and too intent on having fun. But you fooled them. I also remember what they said when you married Douglas. You were a social climber then, an obscure girl who had tossed your loop around the neck of the Crown Prince of Picturedom to advance your own social position and your career. Then again, when you divorced Douglas, the harpies of the press pounced upon you again. They have always pounced upon you Joan and now they are descending again.

They are printing stories that you have gone *arty*. They are saying that you are no longer the old down-to-earth Joan and that you want to be another Duse. They are saying that you have gone high-brow and that Franchot Tone, Frances Lederer and others are a bad influence in your life. They are laughing at your ambitions for the stage and tossing brickbats through the windows of your Little Theatre. They are saying that you are foolishly jealous of Franchot, that you deeply resented his love scenes with Jean Harlow and with Madeleine Carroll. They have criticized the manner in which you have been using your lip stick and all in all Joan, they have been picking you pretty well to pieces.

All of which wouldn't matter, Joan dear, except that your fans are beginning to wonder if these things are true. Letters by the hundreds are coming to my desk. They ask me to tell them the truth. They can't believe these things but they want to know. I'm writing this to ask you if you won't tell them.

● You and I have been friends for a long, long time, Joan. I knew you when you were Lucille LeSeur. I've watched your progress through the years, admired you and respected you more than any other woman I have known. Once you did me a favor about which only you and I and one or two others know for you were never one to make your good deeds public. A great critic recently said, after praising your work in *Sadie McKee*, that you could become the foremost lady of the screen. I agree with him Joan and that's another reason why I'm writing this letter. I don't want you to fail to do it.

But Joan I must scold you a little bit. Recently while talking to a publicity man on the set, you went into a tantrum about these things which the gossips are printing about you. You said that because you study music they charge that you are forsaking the common things. Because you read good books they scream that you are taking on culture and because you built a Little Theatre that you are going in for long-haired theatricalism. You resented their criticisms of your make-up and the way you outline your lips, saying that it is your face

Please turn to page fifty

Dear Gene,

WHAT A PAL you are! Anyhow, thanks for the kick in the pants. Perhaps I needed it. I just finished reading your open letter to me in the August issue of HOLLYWOOD and if talk like that is going around, you can tell the world I want to answer it.

You ask if I'm going high-hat. My answer is, No!

You ask if I'm going *social*, if I've traded my turtle-neck sweaters for a tuxedo. *No again!* I'd rather climb into a leather jacket and a pair of hiking boots and tear out to Arizona in my Ford after deer or cougar than to go to a Mayfair ball any day. Stiff collars hurt my adam's apple and always did.

You've written a lot of stories about me, Gene, and they were good stories, too. Even I have enjoyed reading them and that's something. I'm not responsible for the parts I play but you

Please turn to page fifty-six

An Open Letter To Joan Crawford

and your lips and that you will do what you please with them.

But Joan, is it your face and are they your lips? Can you afford to wear make-up which the fans do not like and outline your lips in a manner which they resent? No, Joan, you can't. You are the Joan Crawford you are today because you incited the love and admiration of millions of men and women, boys and girls. As long as you intend to appear on the screen and as long as you wish to hold their affections, you must be the Joan Crawford they want. Don't you see, Joan dear, what I mean? You no longer belong to yourself but to the millions of fans who love you.

There are many great personalities on the screen, Joan, but few great actors and actresses. You are both. There is not a man, woman or child in America who does not admire you for the things you have accomplished in the development of your personality and your career.

I DO NOT BLAME you for carping at the gossips but remember that your fans do not know you as I know you. They only know what they read in their newspapers and their magazines. Please, Joan, give them your side of the story in your own frank way. They'll believe you, no matter what you say.

Go on, Joan, with your books, your music and your languages. Build your Little Theatre and develop your undoubted talent for the stage. Invite only your close friends, if you want to; that is your business and no one else's. Study and learn and become great; your own career is an inspiration to every girl who wants to rise above the common herd. Only, Joan dear, take your fans into your confidence. Tell them what you are trying to do. Sit down with them and let them know the Joan Crawford I know and they'll stick with you until Doomsday. I'm not asking you to defend yourself, because you need no defense. I am asking you to give your fans, firsthand, the *truth*.

The other day on the studio lot, you passed in your open Ford as I came out of one of the stages. At the wheel was Franchot Tone. With that smile of yours which I can never forget, you turned and waved cheerily at me, "Hello, Gene!"

I had not seen you for months but you were the same Joan. That is the Joan I want you to show to your fans. They are beginning to think of you, because of this gossip, as having drawn yourself away from them. They are beginning to picture you cold and aloof when, as a matter of fact, all of the art, all the culture, all the Little Theatres in the world could never make you anything but warm, impulsive, vivid and generous.

I am not asking you to write to your detractors, Joan, I am asking you to write to your fans. Let your critics stew in their own unsavory broth. Speak to them, Joan, these millions who love and admire you and who want the truth as only you can tell it.

Always,

Eugene Chrisman

Clark Gable Replies

ought to know me too well to think that I've changed any off-screen. Success hasn't softened me, not a bit. If anything, it has hardened me more. The fight to keep on top takes a lot more work than the one to get there and the fellow who lets it soften him doesn't stay on top long.

But where do you get that boiled shirt stuff? I haven't worn a dress suit since *Strange Interlude*. What about *Red Dust* and *Men In White* and even *It Happened One Night*? Was I a softie or a stuffed shirt in any of those? And when it comes to trading mulligan stew for caviar, give me mulligan every time and no matter if I eat it out of a tin can or out of hand painted china and whether I eat it with the right fork or use a bent spoon, I'm still a mulligan eater at heart.

You say that I've come a long way. I have and I admit it. I couldn't be where I am today if I still had the mannerisms that I knew when I was a lumberjack or an oil field worker. A rolling stone might not gather much moss but it picks up a lot of polish, I have, and I'm proud of it. Polish may make a man more of a gentleman but it should not make him a sissy and a softie. Some of the he-est he-men in the world know how to balance a tea cup and wear a tail coat.

YOU SAY THAT Ace Wilfong in *A Free Soul* was my best rôle. I don't think so myself. I liked my part in *It Happened One Night*. That was comedy, of a kind, but I've always wanted to do that kind of comedy. Anyhow, the Ace Wilfongs went out with the gangster cycle.

Then they pick up this race horse business. Said it was an indication that I was going Gene Tunney on them. Do you want to know the real lowdown on why I bought a racing stable? Here it is. I learned to ride in order to get my first big break in *The Painted Desert*. That taught me to love horses. I began to ride a lot, for pleasure and to play a little polo. Then I had an operation and the doctor told me no more riding for a long, long time. I love horses and wanted to be around them, so I bought four racers. I have only one left. That's the real low-down.

Maybe I have lost a little of what you call my punch and virility on the screen. Perhaps I am fed up. I've done a lot of hard work. I can't get the slant that most picture people have, that Hollywood and pictures are the center of the universe. I keep realizing that there is an interesting world outside, places to go and things to do and see. I'm a rolling stone and I'm always wanting to see what's behind the next hill. I'd get away and take that sea trip on a mangy tramp steamer if I could but I'd be afraid that I might never come back. I do the best I can with my hunting and fishing trips.

NOBODY KNOWS better than I, that I am not a great actor. I wouldn't even agree with you that I'm a great personality. I'm just a guy who got a lucky break, that's all. If people like me on the screen and I manage to give a few million people a vicarious thrill, as you say, that's fine. I want to give them the kind of rôles they like, as far as I can but if I ever let it go to my head, I

—Pinchot
Henry Hull, Broadway star of Tobacco Road *will soon be seen in Universal's* Great Expectations

hope somebody will take a punch at it.

Success has changed me. It will change anyone. When I was struggling along, I wanted success, I wanted fame and I wanted money. Now that I've got them, I don't think they are worth what it takes to get them. If I had a swagger and carried a chip on my shoulder it was because I had a goal to fight toward. If I've lost it, it is because I've found that the grass on top of the hill isn't as green as it looked from below. I don't mean to sound cynical. I'm merely trying to be honest with you and with the people who put me where I am today.

If I had a swagger, it was because I had learned in the school of hard knocks that life is mostly bluff. If you want to get what you want, make people think you are good. I thought then that the greatest thing in the world was money, fame, luxury. Now I know that it is to be free. When people get tired of me on the screen, the world is before me. There are a million things I want to do, a million places I want to go. I'm not going to let Hollywood get me down.

Thanks for the letter, Gene, it was great of you to think of me as you did. I hope I've made myself clear. At least I've been honest. I haven't strangled many babies in recent pictures or kicked many cripples but that doesn't mean I'm softening up, going high-hat or trading in my leather jacket for a stiff shirt. Perhaps the rôle I have with Joan Crawford in this picture we're making will convince my fans that Adolphe Menjou's reputation is safe from me.

Sincerely,

Clark Gable

Clark Gable AND Joan Crawford

● ● ● because Clark and Joan thrilled movie fans everywhere with their first co-starring vehicle, *Dancing Lady;* because they're teamed again in another superb picture, *Chained;* and because each represents the ideal of millions of worshippers

THOSE KISSES *Embarrass* THE STARS!

How would you feel if you knew that a dozen pairs of eyes were watching intently while you wrapped your sweetheart in a close embrace and gave her a super-heated kiss? You'd feel pretty darned embarrassed, wouldn't you? And that's exactly the way the majority of the screen stars feel when they have to do a sizzling love scene. Even the most seasoned troupers are often visibly embarrassed. And those who are new to the picture game—well, their embarrassing moments would fill a book.

Franchot Tone's first love scene with Joan Crawford took place under a bed. It was a gag scene. They were supposed to be chasing a cockroach. To say that Franchot was embarrassed is putting it mildly. And the wisecracking comments of those on the set certainly didn't serve to put him at ease.

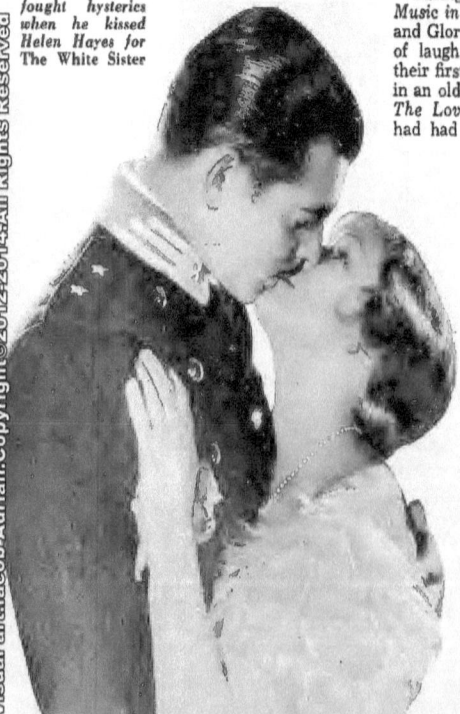

Clark Gable fought hysterics when he kissed Helen Hayes for The White Sister

It is hard to imagine anything embarrassing Max Baer but a love scene with Myrna Loy in *The Prizefighter and the Lady* did the trick. Maxie started to take the lovely Myrna in his arms and then was suddenly uncomfortably aware that his costume consisted of a pair of purple trunks! It is probably the only time on record that Maxie ever blushed.

During the making of *Music in the Air*, John Boles and Gloria Swanson had a lot of laughs reminiscing about their first love scene together in an old silent picture called *The Loves of Sunya*. John had had some stage experience but pictures were new to him. As frequently happens, his first scene with Gloria was a love scene.

"When I took Gloria in my arms," laughs John in telling about that experience, "I was so stiff and self-conscious that she must have felt she was being embraced by a cigar store Indian. She kept telling me to loosen up and relax and assured me that she wasn't going to slap me when I kissed her. 'Just forget all about yourself and imagine that you are the character,' she told me.

"She might as well have told me to imagine that I was Casanova. All I could think of was that here was I, a practically unknown actor, holding the celebrated Gloria Swanson in my arms and kissing her! When the director called 'CUT' I was in such a daze that I never even heard him and I kept right on holding the kiss. When we finally came out of the clinch I had so much lipstick smeared over my mouth and chin that I had to take time out to wash it off before we could go on with the next take."

John confesses that it was not until talking pictures came in and he had a chance to make love in song that he overcame the embarrassment he felt whenever he had a love scene to do.

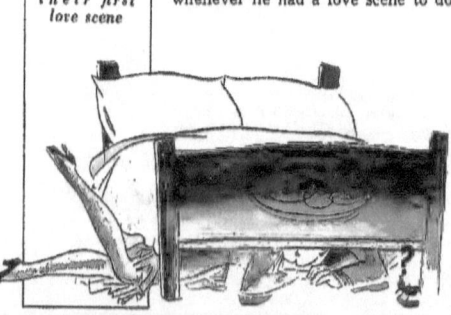

Wisecracking comments of bystanders didn't help Joan Crawford and Franchot Tone during their first love scene

by Grace Mack

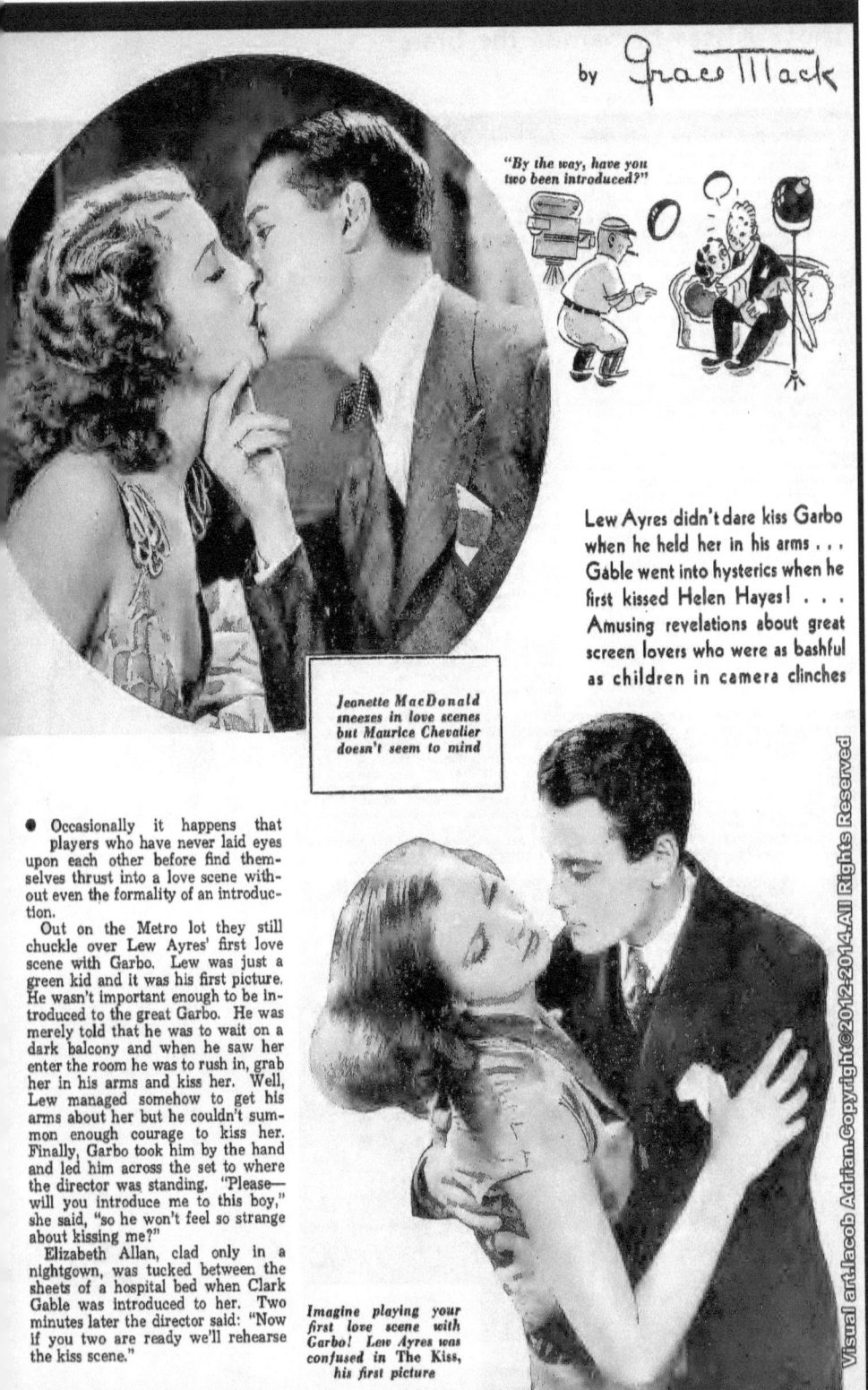

"By the way, have you two been introduced?"

Lew Ayres didn't dare kiss Garbo when he held her in his arms... Gable went into hysterics when he first kissed Helen Hayes!... Amusing revelations about great screen lovers who were as bashful as children in camera clinches

Jeanette MacDonald sneezes in love scenes but Maurice Chevalier doesn't seem to mind

● Occasionally it happens that players who have never laid eyes upon each other before find themselves thrust into a love scene without even the formality of an introduction.

Out on the Metro lot they still chuckle over Lew Ayres' first love scene with Garbo. Lew was just a green kid and it was his first picture. He wasn't important enough to be introduced to the great Garbo. He was merely told that he was to wait on a dark balcony and when he saw her enter the room he was to rush in, grab her in his arms and kiss her. Well, Lew managed somehow to get his arms about her but he couldn't summon enough courage to kiss her. Finally, Garbo took him by the hand and led him across the set to where the director was standing. "Please—will you introduce me to this boy," she said, "so he won't feel so strange about kissing me?"

Elizabeth Allan, clad only in a nightgown, was tucked between the sheets of a hospital bed when Clark Gable was introduced to her. Two minutes later the director said: "Now if you two are ready we'll rehearse the kiss scene."

Imagine playing your first love scene with Garbo! Lew Ayres was confused in The Kiss, his first picture

Those Kisses Embarrass the Stars

It was hard to tell which one was the most embarrassed, Elizabeth or Clark.

DOUBTLESS THE MERE thought of being on the receiving end of a Clark Gable kiss would be enough to send your blood pressure to fever heat. But suppose when Mr. Gable bent over to kiss you he laughed in your face!

That's what happened to Helen Hayes when she played with Clark in *The White Sister*. Helen's imagination leaped to the conclusion that he was comparing her with some of the beautiful, sex-appealing girls he had made love to on the screen and that it had suddenly struck him as amusing that he should have drawn a face like hers to kiss. Now a Glenda Farrell or a Joan Blondell would probably have said: "What's the big idea? I think your pan's funny too but I'm too much of a lady to laugh out loud about it." But not Helen. She was so embarrassed and humiliated that it took all the nerve she could summon to go on with the scene.

When she left the set that night she was determined to find some way to bow out of the picture. But the next day a very penitent Gable broke down and confessed to her that he had had such a bad case of stage fright at the prospect of playing a love scene with an actress so accomplished as herself that when the big moment arrived he simply became hysterical.

PERHAPS ONE OF the strangest love scenes ever recorded took place on location in Arizona when Lupe Velez and Ramón Novarro were making *Laughing Boy*. There were at least two thousand Navajo Indians on the set. The Navajo love technique does not include kissing. When Ramón took Lupe in his arms and gave her a passionate kiss the Indians were considerably puzzled.

"They want to know why he is biting the girl," the Navajo chief told the director.

The director explained that he was in love with her.

"Good Navajo does not bite girl he loves," the chief insisted.

The director tried to tell him that it was "just a story" but the chief quite obviously disapproved of the kiss idea. He translated the director's explanation to the rest of the crowd. They shook their heads and began to mutter indignantly. When two thousand Navajos shake their heads and begin to mutter almost anything might happen. The director shouted "CUT" and that was one love scene where there were no re-takes.

Love scenes *a la* Lubitsch are always very gay and amusing. He wants everybody to be happy and gay because that tends to give a scene that certain champagne sparkle. If anybody shows signs of being embarrassed he proceeds to kid them out of it.

I've heard him say to Jeanette MacDonald and Maurice Chevalier:

"Now I want you to make this scene very, very hot!"

Whereupon they start clowning and give him a strangle-hold that sends everybody in the company into gales of laughter.

"Ugh! That sizzles!" says Lubitsch, pretending to be greatly shocked. "Chill it a bit."

The funny thing about Jeanette is that she has a very sensitive nose. She sneezes when it is hot. She sneezes when it is cold. And it invariably happens that when everything is set for the love scene and the order has been given to "turn 'em over," she begins to sneeze.

"How can I be romantic when you are constantly sneezing in my face?" Maurice complains.

A screen love scene is constructed with one idea in mind: To give *you* a thrill. People go to motion pictures to escape reality, to live for a couple of hours at least a life that is a decided contrast to their own daily existence, and to derive therefrom a measure of synthetic intoxication.

"If the two people playing a love scene let their emotions run riot and feel the scene too deeply themselves," says Jeanette, "then *they* get the thrill and the audience gets cheated. I believe that the most effective love scenes are those where the two people involved merely *appear* to be living the scene—and that's where the technique comes in."

In other words—look hot but keep cool. It's a good trick if you can do it.

Clark Gable and Carole Lombard were among the screen notables who gave their enthusiastic okay at the premiere of A Star Is Born

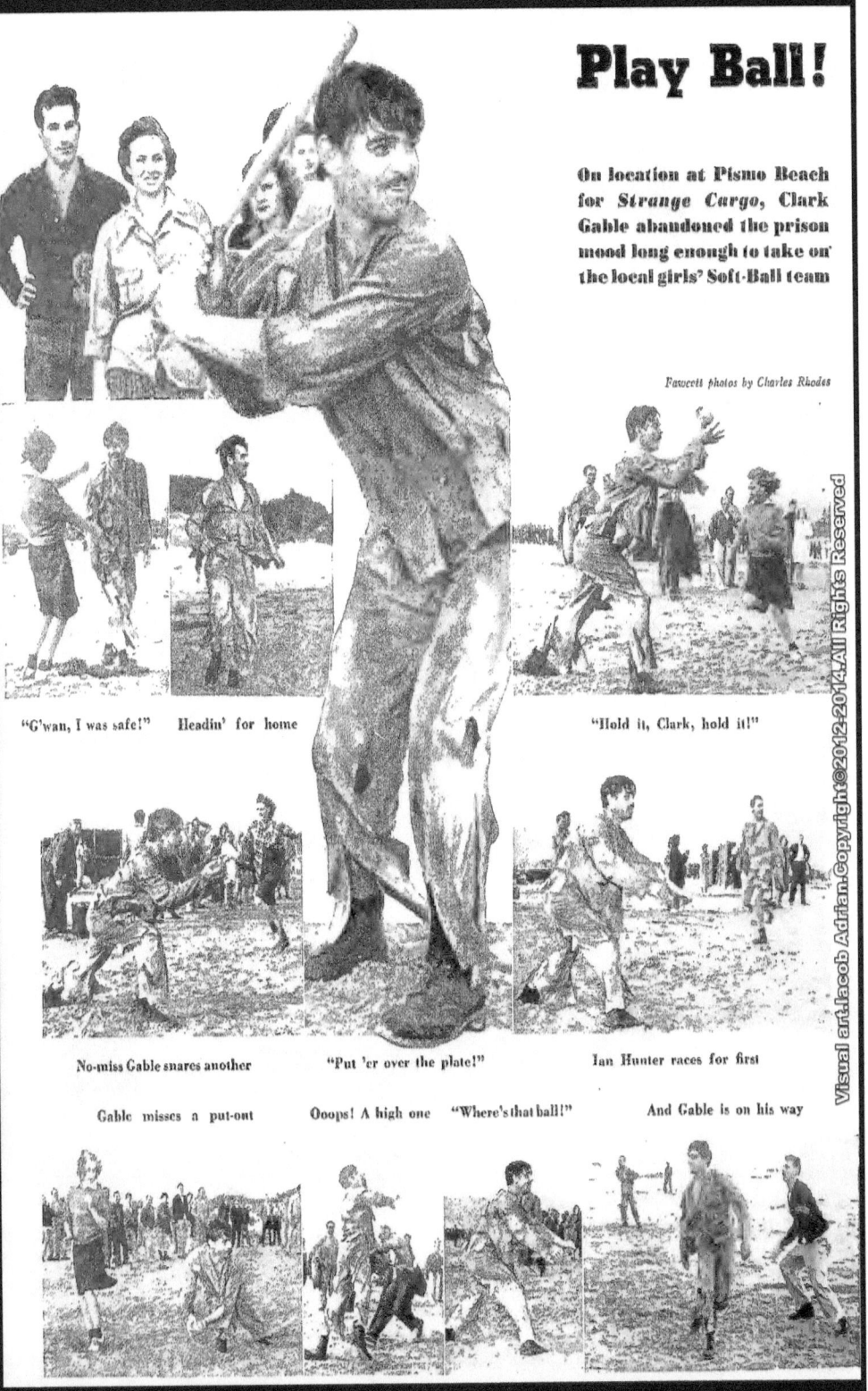

This is CLARK

by ROBERT MONTGOMERY
As Told to Ben Maddox

...in which CLARK GABLE'S supposed "rival" paints a penetrating word-picture of him. And if you don't think they're pals, just read it!

CLARK—as Bob sees him

"His meteoric rise was enough to dazzle any fellow. He could have sat back and taken it easy; but he didn't.
That's one reason why I respect him.
"Clark is like me in that he appears to be light and airy, yet is pretty serious underneath it all.
"A man with Gable's intensity yearns to live life, not just play-act it."

I ONLY HOPE THAT Clark receives as many compliments for me as I do for him! The lovely ladies who act opposite him like him. All the rest of the people on the set, from prop boys up or from the director down, like him. The nicest people about Hollywood like him. I know, because they're always coming up and telling me so!

Now I agree perfectly with the unanimous appraisal of Clark Gable as the most likable sort of a fellow. But I want to confess something. I get a personal kick from the way people look at me when they finish saying a kind word about him.

They speak and then peep at me in a fashion that I can describe most accurately as "suspicious." When I say that I, too, think he's great, they give me that sickly smile and seem to be inwardly murmuring, "The liar!"

Clark and I have often discussed our "rivalry." Since each of us is happily married, any possible rivalry is limited to the studio confines. By those who are informed on state secrets, I mean, Clark and I are the only two in town, I guess, who are uncertain about the whole thing. We get together for "wondering bees!"

But enough of exposing what I presume is a good gag.

● The first time I ever saw Clark was in New York. About a half-dozen of us had gone to Arthur Hopkins' production of *Machinal*, and in the play, in the rôle of a young engineer, was Clark. He made a distinct impression on us.

There was a virility in his performance that set him apart from all the rest of the cast. We talked of him at length.

It was after I watched him score so magnificently with Norma Shearer in *A Free Soul* that I fully realized what a terrific punch he carries.

I don't think there is another man or woman in pictures who has made such definite steps forward as Clark has, either. You mustn't misconstrue this. He was a fine actor when he started on the screen. But every one of us can improve, and not enough of us do.

In spite of Clark's breaks, his progress, in my estimation, has been due to his worth, rather than to luck. His meteoric rise was enough to dazzle any fellow. He could have sat back and taken it easy; he could have gone along elegantly just on personality. But he didn't. He put real thought and effort into every part, and still does. That's one reason why I respect him. The ordinary actor isn't so much different from the person who has to reach for the first olive after opening a jar of them. There isn't much to spur him on to dig down for the other olives. They'll probably roll out.

● Clark is definitely a man's man —in his manner of thinking and behaving, and in his way of living. Although he has been flattered to the extreme, he hasn't let himself go soft.

He has had to withstand more public pressure than any man in Hollywood. Every move he has ever made has been spotlighted. He has had countless opportunities to go haywire. And yet he hasn't. Furthermore, he isn't namby-pamby. He doesn't deny anything he has ever done. Whenever he has made mistakes—and who of us hasn't made plenty?—he has admitted them . . . to the press. Believe me, that takes courage!

When he makes decisions, he stands by them and doesn't hem and haw. You can depend on him and trust him to the utmost. What strikes me as exceptionally com-

Clark Gable

and THIS IS BOB

by CLARK GABLE
As told to Ben Maddox

...in which ROBERT MONTGOMERY'S alleged "public enemy" tells what he likes about Bob—and why. And kills some "silly rumors!"

I WAS A FAN OF Bob Montgomery's for at least two years before I ever met him. And I rated an introduction just five years ago. So, to be frank, all this talk that has been stirred up about our being romantic screen rivals sounds darn silly to me. Of course, we sort of alternate opposite the glamour girls. But I don't hold that against Bob!

We recently vied for Joan Crawford's heart in *Forsaking All Others*. A lot of folks were worried about how Bob and I would get along as co-stars, sharing honors in the same picture. I have a sneaking hunch that they *hoped* we'd squabble for the breaks.

This is the funny thing. They didn't know that we had played together once before. Only then it was my first film at Metro, and I was a humble laundry-man in the plot! If you can recollect back that far, I'm referring to Connie Bennett's *The Easiest Way*. Bob was the dashing hero, and I was rung in for a "bit." Life is strange, isn't it? Now I've just finished opposite Connie in *Town Talk!*

Fight for the breaks? Nonsense! I'd much rather work with a cast that keeps me on my toes than struggle through a story with actors who are second-rate. Bob is a swell performer and the excellence of his technique, the way he can do scenes for all they're worth, is stimulating.

● You know how you acquire pre-conceived ideas about people? Well, the first time I saw Bob on the screen, I spotted him as one of my favorites. Then, when I glimpsed him with Norma Shearer in *The Divorcée* and *Strangers May Kiss*, I was positive that he must be a grand egg.

Robert Montgomery

BOB—as he looks to Clark

"He couldn't be boring or stuffy if he tried, because he's too full of the zest for living.

"One of the qualities I particularly envy in Bob is his ability to meet any situation that may arise. You can't floor the boy!

"There's an amazing contradictory streak in him. He doesn't take things seriously, and yet, undoubtedly, he does."

Unfortunately, I've stumbled upon the sad fact that all that glitters is not gold. Yes, even—or should I say *especially?*—in Hollywood. So when I landed that job in *The Easiest Way*, five years ago, I walked onto the Bennett-Montgomery set mentally prepared for the worst. He might not be what he screened to be.

I remember, too, that no one bothered to introduce me to him at first. Everybody assumed we had known each other on the stage in New York. I guess it was a coincidence that we hadn't become acquainted in the East. Anyway, I finally got up the courage to ask for a genuine introduction.

He and I were kept so busy afterwards that we didn't really have a chance to become friends until about a year ago. And at that, most of our conversation still concerns what we'd *like* to do, what we *will* do. When we have the time!

Bob is not the least disappointing in person. He is the same gay, light-hearted, romantic fellow you see in his pictures. There's a jaunty, friendly way about him that immediately wins your approval. Even his clothes—and he's usually comfortably nonchalant, despite his expensively tailored wardrobe—have a delightfully informal air.

He couldn't be boring or stuffy if he tried, because he's too full of the zest for living. Dat ol' debbil Fame hasn't lured him into "taking it big." He is sincerely interested in people and nearly always has someone with him. Bob isn't moody or morbid. Or arty.

This Is Clark

mendable is that he decides everything from a man's viewpoint—not from the apt-to-be-fantastic aspect of a movie star.

Clark was fortunate in that he had knocked around Hollywood before he ever attracted attention. When you're in the money, I find, people treat you differently from the way they do when you're in desperate need of a job. I know that from my own past experiences. But Clark had his jolts right here. He didn't harbor any absurd illusions when he "arrived," because he already knew what a whale of a difference a little fame and cash make in this town.

Those tales of heart-breaks that you read about, if you'll stop to recollect, center about people who have a far-fetched notion of Hollywood. They come into sudden glory and are swamped by the honeyed words. Or they are utterly discouraged by not getting the breaks. Clark went through all that, then abandoned Hollywood, went to Broadway, and finally returned to triumph—with his eyes wide open.

A trait I have detected in Clark from the beginning is his absolute understanding of himself. It's important that we should correctly estimate ourselves. If Clark has ever deviated, briefly, from his own conception of his abilities, nothing could be more natural—for he is such a target for everyone's ideas as to what he should do. But he can retrace the road to his original self better than anyone I know.

HE DOESN'T GO in for a chauffeur for himself, or for any excessive star trimmings. His idea of relaxation, is jumping into his car and heading for the mountains to hunt. There's a spot in Arizona that fascinates him. The people there aren't film-goers. They don't know who he is; all they know about him is that he's that very regular guy who blows in from California twice a year. He stays at various cabins, pays for his board, and sits up half the nights talking with "the natives"—about everything under the sun.

I hate one-track individuals. Clark tried an assortment of jobs before he ever determined on becoming an actor, and he could get along anywhere. With his adaptability, his intelligence, and his charm, he could step out of the movies and click in any number of other businesses.

You have heard how stars are pestered and how they have to slink down alleys and rush away in deep disguise. Well, let me tell you about this Gable. Frequently, he eats lunch in a little restaurant a half-block down Washington Boulevard from the studio. When he's eating in the studio café, he's generally upon a stool at the counter, tearing into a huge dish of stew. You draw your own conclusions!

His principal virtues are his steadfastness and sincerity. But I can't overlook Clark's tact. He is a whiz at tact. Now, this counts in any line, but it is one essential to sticking around long in pictures. People who probably are not the chummiest of folk are Clark's close friends. What I'd like to know, Clark, is —what's your system?

It isn't being silent, or being afraid to be frank. Clark is not a dodger when you ask him questions. Still, he makes friends of foes. Smart boy—!

Clark is like me in that he appears to be light and airy, yet is pretty serious underneath it all. He plans ahead—not calculatingly, but sensibly. He has a great sense of humor—but he doesn't go in for kidding himself. And he never will.

I REALLY DO want to take a hunting trip with Clark some day. The only time we have ever had a vacation simultaneously, we were three thousand miles apart. I had skipped off to New York. When I heard that Clark was actually free, I wired him: "How about going hunting?" He had a wire relayed back to me. "The doctors have already gone a-hunting for my appendix!" He was doing his vacationing in the hospital.

He has grown to be a confirmed Californian and the big city mob scenes no longer appeal to him. The outdoor life has got him. Being in the open has become vital to Clark. Why, between "takes," he doesn't sit around on the set. He dashes outside and parks in the sun and talks democratically to whoever is at hand.

Still, he hasn't purchased a Beverly estate. Or any home. He owns no fancy star set-up, preferring to rent. There's a restless urge in him that has always dominated him. Since he has been here, a riot in pictures, he has stayed in one place much longer than he ever did before. I'm not so sure that the acting life satisfies him completely, either. A man with Gable's intensity yearns to live life, not just play-act it.

He's generous. But for a while I had my doubts—during the fortnight of the great "duck mystery." It was one of those we're-going-hunting schemes, only I couldn't get off. So Clark went alone and afterwards called me up. "Stop by the house and I'll give you a half-dozen ducks," he said. "Marvelous!" I responded.

I got the package that morning, took it home, and next morning I was served two ducks for breakfast. "Only *two*?" I questioned our houseboy. He nodded. So at the studio I said to Clark, "Thanks for the ducks—all two of them!" He was astounded. "*Six!*" I shook my head. "No, no, my lad, two!" He 'phoned his house, and came back to insist, "They gave you *six!*"

Well, where the four missing ducks had gone perplexed us no end. Someone had done someone else wrong. Finally, two weeks later, I cross-examined my house-boy again. "How many ducks did Mr. Gable give me?" He knocked me for a loop when he answered, "Six." I screamed. "*Six?* Say, let's get together. I'm going mad! Before you told me I had just two!" He grinned. "Yes, sir, *you* had two. But it was a day before I served you and in the meantime Mrs. Montgomery gave a duck luncheon. Didn't you know about it?"

I should be talking about Gable when I can't even keep up with what's happening in my own house! But you see, I like Clark. And now don't you sneer when you read these honest words! I'm going to invite him over for a duck dinner. You can bet; he'll *bring* the duck!

And This Is Bob

WE HAVE THE same pet sports—hunting and horses. We've never gone hunting together yet, because we've never been able to make our time between pictures jibe. As for our mutual interest in horses, Bob is going in for steeple-chasing and high-jumping at present and I'm being a little less ambitious. I merely ride—and speculate as to whether my best horse is going to do right by me when I enter him in the next big race.

One of the qualities I particularly envy in Bob is his ability to meet any situation that may arise. Figuring ahead what you'll do is one thing. Reacting instantaneously is another. You can't floor the boy! His brain functions trigger-fashion and it would take a better man than Gungha Din to stump him.

I remember an amazing incident. He has a farm in the hills of Connecticut, you know, and he plans to retire to it eventually. Whenever he can maneuver a vacation, he heads back there, and he already has his house fixed just about as he want it. The only trouble is that folks have discovered that it's his, and there isn't as much privacy as he anticipated. A fellow has to get off this eternal dress-parade sometime!

Well, one day Bob had been out and, when he returned, he found that a young man and woman had walked up, opened the front door, and were completely at home inside, giving his living-room a minute once-over. Can you imagine such nerve? I'll admit that I'd have been so mad at such effrontery that I'd probably have been completely speechless.

Bob was astounded, but he never let on. "Do you like it?" he queried politely. "Oh, yes," they answered. He says he could tell they were newlyweds and, somehow, didn't realize that there was anything odd about just walking in and making themselves at home.

"I'm so *glad!*" he exclaimed. "Let me show you all around and then we'll have tea!" Bob loves to play jokes on people, but he's a good sport when he's the goat, too!

I'M GOING To tell another incident about him. This last Christmas, he gave a lot of heavy thought to his selection of a present for Brooks Morris—Chester Morris' six-year-old son. Bob finally settled on a fancy electric train. Three weeks before Christmas he had it sent to the Morris home, for Chester to hide away. A couple of days after he had been advised that it had arrived safely, he 'phoned Chester one evening and said he wanted to come over. So what did he want to do? He had Chester pull aside all the furniture in one room and proceeded to plunge into the mysteries of setting up that train and seeing it run in all its complicated glory!

But there's another side to Bob, also. I am sure you have sensed this from his screen portrayals. After all, a man who was all gaiety would grow tiresome. Bob has his serious moments.

As a business man, for instance, he is very shrewd. He didn't fall into his Hollywood success. There were years on the stage when he was struggling along on a small and shaky salary. So he has behaved with praiseworthy foresight since establishing himself in pictures. He lives comfortably, but he hasn't bought a mansion. He rents a house from John Mack Brown. He isn't putting on any front to impress. His home is for his family and his friends. His earnings are carefully invested.

Bob isn't gullible. And, believe me, that's a very helpful characteristic out here. They don't try to sell you the subway, or the Empire State Building, but practically everything else can be had "at a great bargain, just for *you!*"

THERE'S AN AMAZING contradictory streak in him. He doesn't take things seriously, and yet, undoubtedly, he does. It's difficult to explain. All the hullabaloo made about stars doesn't fool him—he accepts it as fun and phoney-business. But he is profoundly concerned, nevertheless, with things being as they *should* be. He's still idealistic.

He is one of the leaders in the Screen Actors' Guild and is constantly battling for justice, for better conditions for the actors. Not just for himself, but for our profession as a whole.

I hate to go through a picture with those extraordinarily arty souls who have illusions of grandeur. They carry on as though they had the weight of the world on their shoulders. They can't be natural for fear it will shock the prop-boys—or spill the beans about themselves! Bob, now, goes at it with a keen sense of humor. He enjoys the actual acting.

I should say that he ranks extremely high as an actor, too. He has an obvious charm of personality, and more. Bob has studied, debated, which are the best ways to give certain effects. In other words, he is skilled at his trade. And that means something. His personality, which is unique, put him across in Hollywood. But his earnestness, his mastery of the technique of acting, will keep him on top here as long as he wants to stay. I don't think there's a better light romantic actor in any studio.

THERE I COME back to what may hit you as still another paradox. You might suppose that he achieves perfection in his particular line by simply breezing onto the set and rattling off his dialogue. He does "toss off" his speeches. That is, he delivers his dialogue in a human, unaffected manner. He isn't one of those hammy actors who drums in his meanings to the audience.

Yet, strangely, I have never found Bob "ad libbing." He is spontaneous, but he is diligently prepared to be. He knows his rôle to the last nuance, learns his part and doesn't trust to improving it on the spur of the moment. Nor is there any foolishness about getting into a mood. He has figured it out the night before. So he can be gaily chattering with someone and then suddenly walk before the cameras and do a big scene.

I'm a past master at "going up" on lines, myself. Bob never does!

We're going to work together again soon, in "Mutiny on the Bounty," and there's a lot of swell swashbuckling written in the script. It's an assignment that suits me to a T. Montgomery is the kind of guy I favor having around—quick, bright, and continuously amusing. But perhaps you've already got my idea. Bob is a bit of "all right!"

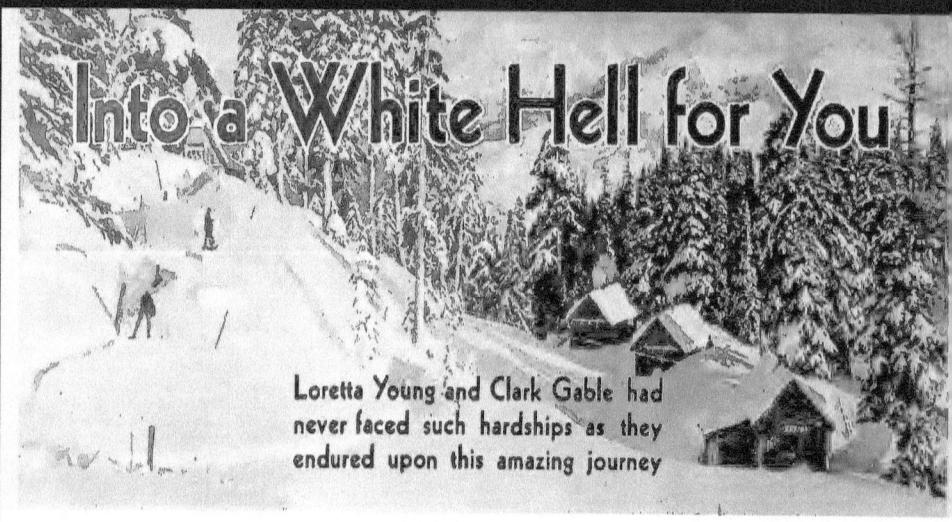

Into a White Hell for You

Loretta Young and Clark Gable had never faced such hardships as they endured upon this amazing journey

by JACK SMALLEY

● As YOU MOVIE goers sit back in a comfortable seat in your favorite motion picture theatre, do you ever think of the hardships—sometimes almost incredible hardships—that a group of film workers suffered to make possible your entertainment?

When 20th Century's *Call of the Wild* company left the studio, they planned to be gone ten days or two weeks. But they reckoned without the frigid grasp of a northern winter. Held by the icy blasts of blizzard after blizzard, the weeks lengthened into more than a month of privations from cold and threatened starvation.

Without warning, the blizzards struck, isolating the little group from the base of supplies. Telephone wires were torn down by the storms, and after more than a week, short-wave radios re-established communications. With food supplies running low, restricted rations were necessary. They did not know, as they carried on, that their hazards were increased by avalanches and washed-out bridges in the floods below their mountainous location. Imprisoned and facing hunger— the photograph above shows how completely they were snowed in —aid finally reached them via relays of snow plows, trucks and dog teams.

● THOSE HELLISH, frozen weeks on location atop snowy Mount Baker in the State of Washington! Difficult to picture, in the midst of California summertime, the incredible hardships suffered by Loretta Young, Clark Gable, Jack Oakie, Director William Wellman and others among that intrepid band of the *Call of the Wild* company when snow covered the cabins ten thousand feet above the sea, when open fireplaces failed to heat summer resort hotels with the thermometer twenty below!

"Nobody expects to believe that a pampered film player ever is exposed to real hardships," Loretta told me, "but if you could have seen what we went through—! It was no press agent's dream, the rigors of that location trip.

"It might not have been so difficult for me had I been accustomed to cold. Although I was born in Salt Lake City, where winter is frigid enough, I was brought to Hollywood when very young, and lived all my life in sunshine and palms. When we got to the jumping off place near Mount Baker, I was unable to adjust myself to the cold. And it was bitterly cold, with worse to come.

"When we attempted to make the location camp on Mount Baker, our party had no sooner been bundled into cars when we met the studio trucks returning. Snowslides had blocked the roads. There was no hotel at the little settlement at Glacier. We were stumped.

● "FORTUNATELY Mr. and Mrs. Graham of Glacier made room for Mr. and Mrs. Reginald Owen, my companion, Mrs. Frances Earle, and me. Bill Wellman and Dorothy, his wife, pushed on by dog sled next morning, and then a snowplow cleared the way for the rest of us. That was our introduction to the hardships to follow.

"A flimsy sound stage had been built near the summer lodge on top of Mount Baker, in case of blizzards. We drew a blizzard immediately, and tried to work on this stage. Wind whistled through it. My nostrils frosted shut, my feet seemed like cakes of ice. In that bitter cold, we could shoot for only a half hour at a time.

"We slept in the cabin annex to the hotel which had burned down, with little heat and all sorts of discomforts, but not a soul complained. Mrs. Clark Gable stuck it out valiantly, but she and I almost lost heart when one night the power plant broke down. Without lights or electric heat, we were ready to freeze to death for dear old 20th Century. I felt so sorry for the crew sent to repair the plant that I forgot my own discomfort, and how we cheered them when they returned, successful, after battling three solid hours to reach the power plant through the snow. One of the boys passed out, and came very close to giving his life to save the rest of us from surely freezing.

"Clark and Jack Oakie and Director Wellman made life bearable with their

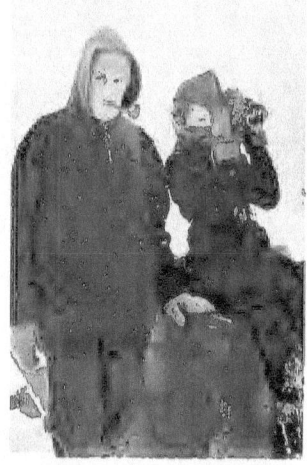

Director William Wellman and his wife, Dorothy Coonan, muffled to the eyes, dared snowslides to reach location

unfailing good humor—though sometimes Jack also made life almost unbearable with his gags. But you have to forgive him—he is so contrite and innocent looking when he confesses a prank.

"WE HAD plenty of frozen meat, but we were soon starved for fresh vegetables. I developed a tremendous hankering for a stick of celery—just one little piece of celery would have made me happy. For five days, we couldn't even leave our cramped quarters, with the snow over the tops of windows and a howling blizzard raging. The partitions that divided our chicken-coop rooms were as thin as paper and afforded only visual privacy.

"Mrs. Earle had a birthday, and the chef stirred up a cake. We had speeches and celebrated grandly. Then Clark announced his birthday, and we celebrated again. I regretted that my own birthday, on January sixth, had arrived before our location trip. These little parties were a god-send to keep our minds off the privations.

"Making our way about camp required a guide to get us through the maize of deep cut snow paths. They seemed to lead everywhere. One night, we tried to find our way to the mess shack without our guide, Harvey, and became lost. Finally, we saw a light and got back to the cabins, but we were as frightened as we were frozen.

"There was real danger—avalanches, for one thing—all about us, as we all knew, but the players and crew never became discouraged nor lost heart. Wellman kept things in an uproar. There was never a dull moment if he could help it.

"After Mrs. Earle sprained her ankle and another member of the party crushed a knee cap on the slippery paths, we went around with ski sticks to keep from falling. It was a thrilling experience, but I'd hate to repeat it!"

Their supplies had to be brought in over sixty miles of mountain road from Bellingham, with the constant danger of snow slides blocking the way. All the males in the cast bristled with beards, which collected icicles in that brittle cold weather. Cabin roofs groaned under the weight of 30-foot drifts, windows glowed feebly from what light filtered through the snow.

The power plant episode described by Loretta nearly ended the location trip. A break occurred in the power line sometime after midnight, and the suffering community knew that all pipe lines would soon freeze and burst. The work of the crew was truly heroic in repairing the damaged line which was found by frantically digging through drifts. No less real was the danger of food shortage when a chinook (warm wind) melted drifts, flooded lower roads, washed out bridges, and no supplies could be brought in. Dog sleds finally got through with provisions in the nick of time.

The picture, all agree, is worth it. *Call of the Wild*, most famous of Jack London's tales, is another triumph for youthful Darryl Zanuck.

Loretta Young, delight of directors and cameramen, is Cecil B. deMille's choice for *The Crusaders*, in which she now finds herself in other difficulties. But the hazards of such a picture will be nothing compared with the incredible hardships she suffered on location in a white hell for you.

Imagine working in a snowstorm like this. Clark Gable and King, the St. Bernard, acted while blizzards raged

Loretta Young needed all of those furs and more. Yet she smiled bravely

What I Think JEAN HARLOW

by Clark Gable

Two Pals — other, Mark

To Me, Jean always seems to have rather a man's attitude toward life. I don't know just how to explain this, but I always feel it when I'm with her. You can talk to her so naturally. She understands and appreciates the things men are interested in. Of course this appeals to any man.

Instead of the slinky evening gowns and bizarre costumes you might expect her to wear, after seeing her on the screen, she usually goes around in a pair of slacks, or a sports skirt, short socks, and sneakers. She seems utterly unconscious of her beauty.

She adores golf. She is an expert fisherman. She loves riding. And she makes no allowances for herself as a woman in these sports. She plays them on an equal basis with men—and discusses them more intelligently than one woman in a hundred.

She never uses her femininity in conversations—to win arguments, for instance, or to put over a point. So many women suddenly "go feminine" when they think it will turn the tide their way, but I don't think Jean even thinks of her sex in such circumstances.

● She Has, Too, a complete sense of fairness. I don't know anyone, man or woman, who is more of a straight shooter. She is fair in the things she does and the things she says. I have seen her, on one occasion, give a bit player an unusual break. The girl had a short line to speak, and then Jean was supposed to interrupt her. The girl had tried awfully hard, but as the scene was to be played she would be hardly noticed. Jean said, "I was an extra myself once, so I know what this means to her. Couldn't we change the script a little so my line can be delayed—and so I won't have to walk in front of her?"

I've never known Jean to "go temperamental," and when you consider the number of days we have worked together, this is a real tribute. I have seldom seen her out of spirits. Of course, she's human, and she has occasional flare-ups. But they last only a short time and are always directed where they belong. Usually she is right.

She's a swell sport. For instance, if I have to "sock" her in a picture—and believe me, it is done with the utmost reluctance!—she never asks me to take it easy. She doesn't expect me to. When I "dunked" her in the barrel of water in *Red Dust*, she didn't seem to mind at all. I'm always a bit embarrassed about such scenes, and her attitude helps. It's just part of the business to her, and she goes through the retakes, if they're necessary, like a trouper.

Again, during the making of *China Seas*, she had a bad cold, and right in the middle of it we had

About
CLARK GABLE
by
Jean Harlow

expose each

as told to

Dowling

I CAN'T IMAGINE anyone I'd rather have for a friend than Clark Gable. He embodies all the qualities which are necessary for true friendship.

Not more than half a dozen people in Hollywood, I believe, know Clark as he really is. He is so much deeper than people think. He won't talk about himself—he doesn't even seem to think much about himself. It's not that he's a Garbo. But he is always so interested in finding out about you that he never tells you much about Gable.

But I know him from the standpoint of one who has worked with him on many pictures. I believe that by working with a man you get to know him as well as anyone possibly can. If he stands well in the opinion of his fellow-workers, he'll be the same under any conditions.

We started our screen partnership several years ago in *The Secret Six*. It was my first picture after *Hell's Angels* and it was, I think, Clark's first important picture. Since then we have played together in *Red Dust*, *Hold Your Man*, and now in *China Seas*. The most revealing comment I can make about Clark is that he is, today, the same human, natural, amusing chap he was in the beginning.

He has made a spectacular success. His rise to the top is breath-taking even in Hollywood, where overnight fame comes fairly often. He is probably every woman's ideal of a man, as a husband, friend, or a lover. But Clark is no more conscious of this than he is conscious of the color of his eyes. Maybe even less so! Fame hasn't changed him.

For instance, his stand-in now is a man who worked with him on the stage some ten years ago. Clark's attitude toward this chap is that of a friend and a fellow-worker. He doesn't seem to have a trace of a feeling that would be, after all, quite natural in the circumstances—"I'm the star and you're the stand-in!"

There's one exception, one change that has come inevitably with success. When Clark and I made *The Secret Six* we had no particular incentive because it seemed too wildly improbable that we would become stars. We regarded each bit of success as a lucky "break" and made the most of it. Our attitude was happy-go-lucky. We enjoyed ourselves as we went along.

Now Clark regards his work with an increased seriousness. He takes each part more intensely. The best way of putting it is to say that he has an *increased application* to his rôles.

● HE IS ESSENTIALLY a man's man. His attitude toward me is that of a pal or a brother. With some men, you are made awfully conscious of being a woman.

What I Think About Jean Harlow

another scene where she had to be soaked. She didn't complain once, though I'm sure it was anything but pleasant for her. And if she didn't have such radiant health, it would take her weeks to break up the resulting cold.

One of the characteristics I have in mind when I say she has a man's attitude is her amazing sincerity. She is always perfectly frank. There is no halfway about her, she treats everyone the same way,—director, producer, or fellow-actor. When we were making *The Secret Six*, Wallace Beery once criticised her for some minor detail of her performance. Without hesitation she flared right back at him. Remember, at the time, her position wasn't nearly so important as his. But he admired her frankness—I believe their friendship dates from that day.

She never keeps things pent up inside herself. She doesn't nourish a grudge. If she has anything to say, she brings it out into the open, and then forgets about it. I like that.

● LOOKING BACK on our first picture together, the talks we had will always stand out in my mind. After her success in *Hell's Angels*, she was a step ahead of me on the way to success, yet she never made me feel that it was her picture any more than mine.

Neither of us knew much about the business, and we tried to figure things out together so the rest wouldn't realize how awfully green we really were. I remember Jean would ask me at the end of every scene—"How'm I doing?"

And I asked her the same.

We criticised each other, trying desperately to learn. Nobody else seemed to pay much attention to us. We were not among the chosen few who saw the daily rushes. Every good word Jean heard about me, she would rush to repeat to me. And things that weren't so good, too, because she knew that is one way of progressing.

We used to plan, jokingly, what we wanted if we ever did get to the top. Jean never particularly wanted fame. The lights and the crowds and the glamour of being a star never seemed to mean much to her, even before she had them. She wanted, sincerely, the happiness of knowing she had done a job well.

If you talked to her directors and other fellow-stars, I think you'll find that she feels the same way today.

She was, I remember, terribly afraid of being typed in "vamp" rôles. She was afraid that her part in *Hell's Angels* would mark her forever in the eyes of the fans. *Red Dust* wasn't much better. But she didn't complain.

She is, in my opinion, one of Hollywood's best comédiennes, and I feel that she is right in wanting to do more comedy. Certainly few stars in Hollywood could have equalled her wonderful performance in *Bombshell*. I hope she is given the chance to do more pictures like that.

She is a thoughtful person, considerate of those around her. Every morning she has coffee and doughnuts on the set. Instead of ordering one cup of coffee and a couple of doughnuts sent to her dressing room, she orders a huge pot of coffee and a couple of dozen doughnuts for the entire company.

Because of little things like this, every extra I've ever talked with adores her. Sometimes they are critical of other stars, who may be, in their eyes, ritzy or up-stage. But Jean stands ace high with all of them.

Having grown out of the extra ranks herself, she has not forgotten her friends and acquaintances among them. Out of every crowd, on our pictures, she will find a familiar face or two. It's always—"Hello, Eddie!"—"Hi, there, Janet!"

● SHE HAS boundless enthusiasm—a quality so many people outgrow. In many ways she is like a kid in her pleasure over little things. Just the other day a property boy who had worked with her on *Bombshell* brought her a live rabbit. She couldn't have been more pleased if it had been an expensive gift.

Because they like her, everyone who works with her tries to make things easier for her—even though she isn't a demanding person, and prefers to do things for herself. She has told me of making the dance scene in *Reckless*. She had never danced for the camera and was terribly nervous. She had to do her stuff in front of a hundred or so bit players—all of them chosen for their expert dancing. If they had so much as whispered a word of criticism, she told me, she wouldn't have been able to go through with it. Instead they applauded her, and kept crying out, "That's the stuff, Jean!"—"You've got it now!"

And their enthusiasm meant so much to her that by the third "take" she was dancing like a professional!

It has always been a bond between us that we started at about the same time, and our progress has been more or less parallel. Neither of us can remember, 'way back to the silent days." We went to the same class in the same school, in other words, and we've been promoted in the same pictures. Of course, in between, we each went separate ways, she with other leading men and I with other leading ladies.

After a picture, we make no effort to keep up our friendship. But when we see each other again, we seem to pick up where we left off, regardless of what has happened to us in the meantime. It's marvellous and rare to have a friend like that. Most friendships are lost unless they are kept alive.

Probably this outburst puts me in the class of her fans. I am. And I think you'll find that everyone who really knows Jean feels just the same way.

Gable did not kiss

What I Think About Clark Gable

you think, "Maybe my nose is shiny," or "Does my hair look right?" or "What if my lips aren't on straight?"

With Clark you don't care if your nose is powdered or not, or whether you have on an old pair of slippers. You feel that he likes you because you're a human being. You can be at ease with him, comfortable. This may seem a small point but it's awfully important to me. Or to any woman—I've noticed the same reaction in others. I think it's an important part of Clark's charm.

He's a completely natural person. He does all the little things for a woman that other men do—offers me a light for my cigarette, pulls out a chair for me, and so forth. But so many men have rather an air of preening themselves when they're being gallant. Clark, quite naturally, wants to help you. And his unobstrusive way of offering the small courtesies represents true gallantry. Women must sense this through his screen performances. I believe it's another explanation of his success.

● HE IS highly considerate. He always seems, for instance, as vitally interested in my problems as in his own. Sometimes when we rehearse I have difficulty with a bit of dialogue. A line won't read in a way that sounds natural to me. Or perhaps it is out of character with the rôle I'm playing. Nine times out of ten Clark will say, "How would it be if Jean read the line like this?" Then he makes a suggestion that solves the problem.

I have the feeling that he is just as anxious for me to give a good performance as to give one himself. For instance, if we're doing a scene which is more important to my rôle than his, he still gives of his best to help me. Even if it's just a business of "feeding" me a line.

He is amusing, humorous. It is difficult to write of jokes and casual conversations—they always sound a bit flat when repeated. Between scenes we often talk of horses. I'm crazy about riding and of course polo is one of Clark's main loves.

He is interested in all sorts of things, and all sorts of people. I believe this is another explanation of his charm. He loves talking to all kinds of men, learning their hopes and ambitions, the way they live. Often he goes over to the extras and chats with them. In our present picture *China Seas*, we have a lot of Oriental extras and Clark enjoys talking to them.

Of course they all think him a "velly nice man!" One of them spent hours whittling away on a bit of wood, making a curiously complicated puzzle which he presented to Clark.

Our sets always have this nice feeling of friendliness between the extras, the bit players, and all the others. It would be difficult to work under any other condition. With everybody Clark is kindly and understanding. And if he can be so considerate toward these people—who really mean nothing to him—how much more would he be toward a friend!

He is dependable, too—another important quality in friendship. I feel that he would be big enough to handle any situation with complete ease. He never fusses or frets. He looks clearly at a problem and sees the right thing to do. He seldom argues. Quietly, he thinks things out, and then what he says always has real meaning.

He is, of course, an excellent actor. (And I believe it is an important indication of character when a man excels at his trade, whatever it is.) As a working partner, I couldn't ask for more. He gives so much to each part that I *have* to keep up with him. He constantly keys me up.

Today, for instance, we did a scene in *China Seas* in which the suspense is terrific. It was a difficult and dramatic bit. Yet Clark was so vibrantly master of the scene that he gave me something to shoot at.

● PERSONALLY, HE has more stability than many men I have known. You feel this when you talk with him. He seems to know where he stands, and where he is going. He won't change.

Even more important, he has the ability to follow-through. I admire that tremendously. He has made a success and stuck with it, even though there have been times when it wasn't easy.

I have seen him, for instance, work *twice* as hard for a rôle in which he didn't quite believe as he would have worked for a rôle he really liked. He never quits on the job for any reason. He wouldn't be a fair-weather friend.

There! When your editor suggested that I do this story telling "what I think of Clark Gable," I warned him that it might sound like a Pollyanna yarn. Perhaps I've been too darned complimentary. But anyone who knows me will realize that I couldn't say such things unless I whole-heartedly meant them. And sincerely I think Clark Gable is the grandest guy in the world

A CHALLENGE TO ALL SCREEN HISTORY

Think back to your greatest film thrill! Recall the mightiest moments of romance, action, soul=adventure of the screen! A picture has come to top them all! For many months Hollywood has marvelled at the stupendous production activities at the M=G=M studios, not equalled since "Ben Hur"; for many months three great film stars and a brilliant cast have enacted the elemental drama of this primitive love story. Deeply etched in your memory will be Clark Gable as the handsome seafaring man; Jean Harlow as the frank beauty of Oriental ports; Wallace Beery as the bluff trader who also seeks her affections. "China Seas" the first attraction with which M=G=M starts its new Fall entertainment season. We predict its fame will ring lustily down the years to come.

CLARK GABLE
JEAN HARLOW
WALLACE BEERY

CHINA SEAS

with
Lewis STONE • Rosalind RUSSELL
Directed by Tay Garnett • Associate Producer: Albert Lewin

A METRO=GOLDWYN= MAYER PICTURE

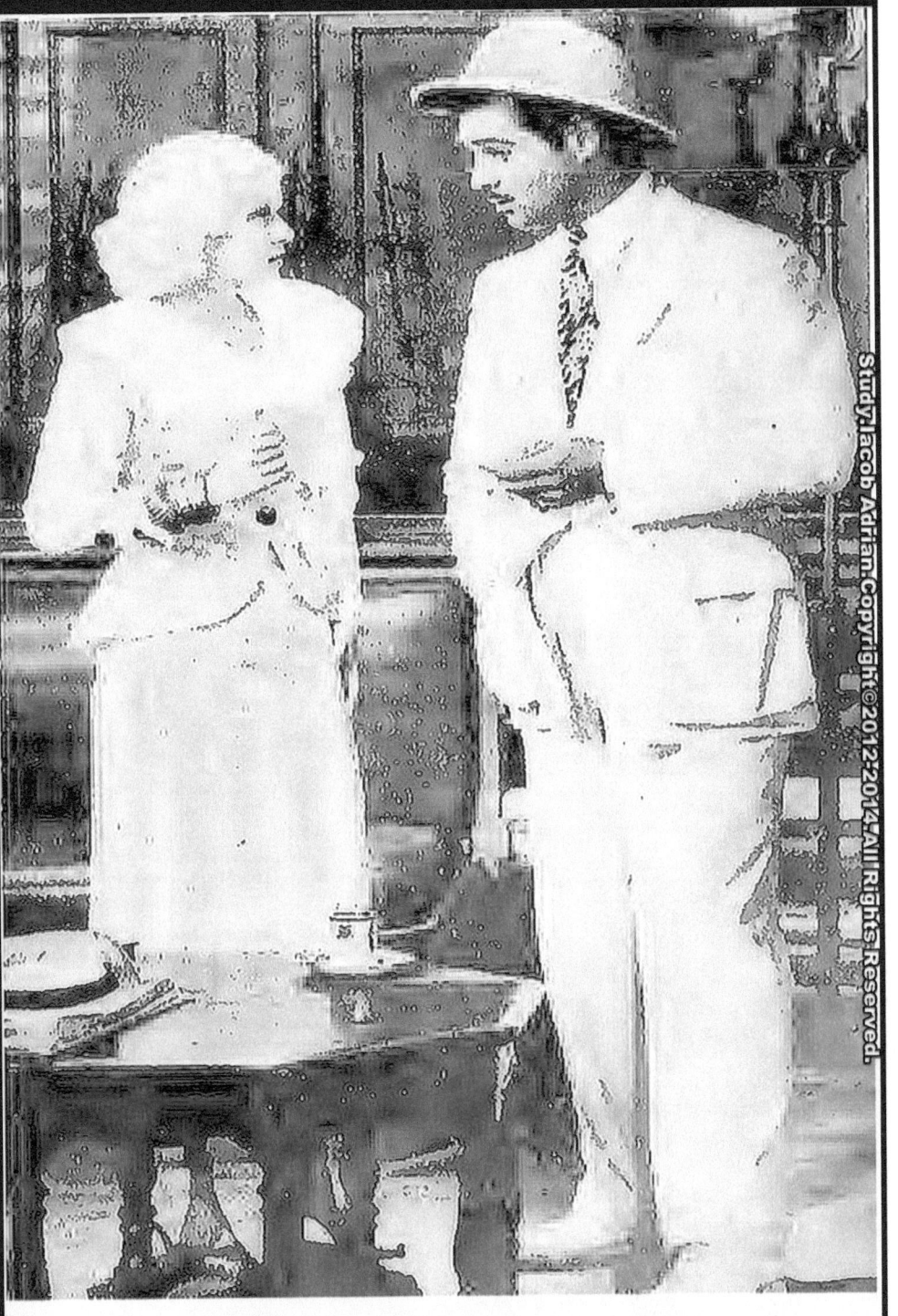
Jean and Clark Gable doing a scene together in *China Seas*

CLARK GABLE,
A Nice Mugg

Jimmy picked a man sized job when he decided to interview Gable! This is for men only

by James Gleason

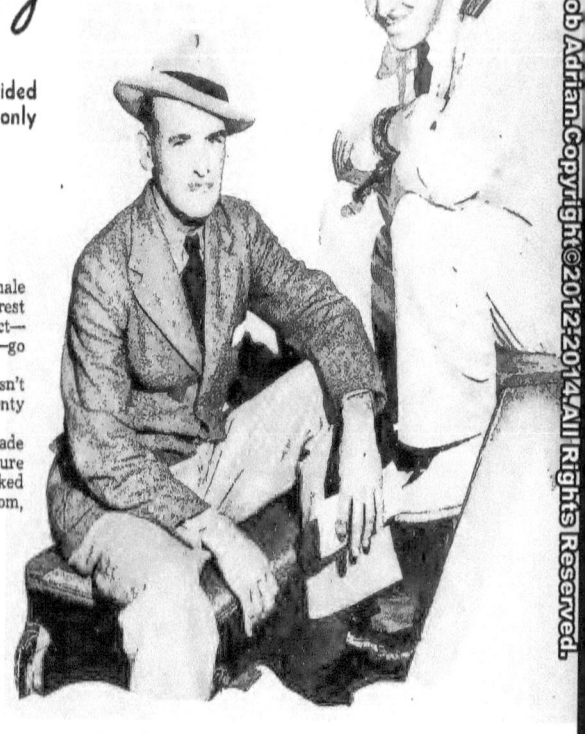

Here's Gleason, your demon reporter, with Gable himself, who couldn't be more close-mouthed if he used a zipper!

THIS IS NOT FOR WOMEN. If you are a female ... of any age ... don't read this, it won't interest you in the least. It should be labeled, in fact—FOR MEN ONLY. Oh, well—since you insist—go ahead and read it then.

How come I came to interview that guy Gable doesn't matter, the fact that I did interview him and got plenty out of it, does.

From the time the date for the interview was made until it actually came off I was busy trying to figure out a lot of questions I'd ask him. Hah! I never asked one of them! We got nicely seated in his dressing room, when—just to break the ice I said: "By the way, Clark, how're the ponies?" Well, that was all. Off we went in a cloud of—*well*, anyway, off we went. He told me about *his* horses and I told about *mine*—then we tried to talk each other down about all our horses. Just a couple of horsemen going to it. I didn't get in one question I'd meant to ask him. I did, however, find out one thing: *What he is aiming at when he quits pictures and settles down*—yeah, you've guessed it—HORSES. He aims to have a breeding farm, somewhere, and breed fine horses. Mostly thoroughbreds for racing, but I imagine he'll raise a few polo ponies and some jumpers and gaited show horses too—but the racing thoroughbreds will predominate. He loves to see the horses go galloping around the turf.

He didn't bring it back alive! Clarence Brown, M-G-M director, shows Clark Gable the rattles off a diamond-back rattlesnake he killed in Beverly Hills

AND WHAT A GOAL that is to aim at! And the best of it is, he'll be good at it too. He's good at everything he tries—skeet—he's a swell shot; riding—in all its forms and that includes polo. (The studio won't let him play, that is, only between pictures. And as far as he's concerned that spells no dice). But he'd make a honey of a polo player; acting—well, I'LL leave that to you—for me he's *swell*. The only thing he does that he doesn't do well is talk about himself. At doing that the guy is a dead loss. And you're talking to a mugg who knows.

He'll talk about pictures—the stories—fellow actors—the stage—carrots—diets — the trout season — who's the best in the heavyweight class—the price of silver—whole wheat vs. white bread—the N. R. A.—or which is the best liniment for a bowed tendon in a horse—but don't ever—if you live to be a hundred years old—DON'T EVER ask him about Clark Gable. He won't even give you a hint. For instance—how's this for a few questions and answers:

Q. How are you going to be in this picture? (*Mutiny on the Bounty.*)
A. Yeah. What's your horse for the Santa Anita Handicap?
Q. You were swell in *It Happened One Night*.
A. I'll bet the salmon are running in Oregon now.
Q. Who do you think you're most popular with — women or men?
A. I made twenty-five straight skeet-shooting against Captain Billy Fawcett.
Q. Do you lose

[*Continued on page 47*]

Stars Own Stories

Clark Gable, a Nice Mugg

yourself in each part you portray?
 A. How would it be if you were to find yourself a nice lake for purposes of jumping in?

● THOSE ARE just samples. Try asking him sometime and see what he says. What I just said above about answering questions about himself goes for everyone and every time. BUT once in a while he lets his hair down and turns loose a little. Not often—just once in a great while. And you've got to be on the job every minute or you'll miss it. It's something that happens to his eyes. He sort of opens the door and lets you in for a minute—and when he does it's great.
 He's a nice guy, that Gable. A mugg—sure—but a nice mugg. I've known that Gable for several years. Met him at parties—on sets—at lunch—dinner—the track—riding—all sorts of places and under all sorts of conditions. I've never seen him paw the ground over a little thing. I've never heard him put anyone on the pan—children, dogs, horses and drunks come to him readily—yes, and sober grown-ups too.
 Yes, sir, that Gable is a nice guy!

HOW DOES GABLE DO IT?

He's been miscast, he's been divorced, he's had unwelcome headlines in the press, but after nine years on the screen he's still tops! "HOW DOES GABLE DO IT?" The secret of Clark Gable's amazing success is revealed in an exclusive article in the July MOTION PICTURE Magazine.

In this same issue you'll find a beautiful colored portrait of popular MICKEY ROONEY, wonder boy of the screen. Printed on heavy paper and free of printed matter, this portrait is one you'll want to keep and treasure.

MOTION PICTURE
10¢ AT ALL NEWSSTANDS

Read
The Self-Education
of
CLARK GABLE
—a remarkable story of achievement told for the first time! Also in this issue: "How to Dance for Money," by the famous instructor who taught Fred Astaire. Read all the news first

CLARK GABLE
Warns Stenos What Happens

WHEN HUSBANDS GET

by
WILLIAM ULMAN

CLARK GABLE grinned. It was on the set while they were shooting the ice-rink sequence for *Wife Vs. Secretary*. He started scraping the ice with the point of his skates, piling the crust into little mounds and then absently brushing it away.

He was still grinning when he looked up. "The office husband problem is a tougher subject to talk on than politics—unless you stick to the fence, and I don't like people who do that. Anyway, I've never worked in an office so I wouldn't know much about that, but, just from the way you have to figure these things out for a picture, I'd say that office wives have to be as careful as office husbands—and the poor bosses are sure on the spot.

"Look at it this way," he said, warming to the subject. "The girl in the office is apt to have a tendency to idealize the guy she's working for. After all, he pays the checks, is 'Mr.' So-and-so and is something of a big shot in his comparative field. Her whole job is to build that guy up so that he seems to amount to something even if she knows darned well he isn't half that good.

"A lot of them get to believe it themselves if 'the boss' is at all attractive, but the thing that the office wife is apt to overlook that the house wife can't, is that this big, bold, dashing man of affairs with the super-

Meet the Wife, Husband, and Secretary in M-G-M's film, *Wife vs. Secretary*. Myrna Loy plays the rôle of jealous wife, and Jean Harlow is the beautiful secretary. Well, it does present a problem, doesn't it?

salesman's personality is also subject to hang-overs, may even wear bed-socks and probably has a foul disposition before his orange juice or bromo seltzer.

● "THAT'S ONE SIDE of it. But now take the spot Van Sanford was in after Faith Baldwin got through with him. He was in love with his wife. He had a grand looking girl in the office who practically ran the business for him. She was crazy about him. He liked her a lot—nothing serious, just mutual understanding and respect couple with a common interest in the business. A strong bond? Certainly! But any woman who hasn't the self-confidence in herself as a wife to meet such a situation and call it for what it is worth, is either going to worry herself to death anyway or lose her husband's respect—and, eventually, love—by unfounded jealousies.

"In the picture, Myrna Loy, as Mrs. Sanford, does have that confidence in herself and it brings them back together again after a temporary split growing out of malicious gossip. People in real life are continually faced with that problem if either one of them are at all attractive. The triangle is the world's oldest story, but it's how a certain set of characters react to it and what they do that make it interesting.

"I don't think that the office wife situa-

Preview-minded. Here's Gable with pretty Jean Parker, attending a Hollywood preview

alliance to circumvent a man they both like, and make sure that he puts on his rubbers or doesn't forget to take his pills an hour before lunch, he's sunk!

"But it's swell for the girls and they aren't as apt to be so suspicious of one another. The type of man who pulls the old 'misunderstood at home' line might just as well fold up his tent and remain on the reservation. Which he deserves for his lack of originality in excuses. Likewise the wife soon learns to play better bridge because she isn't spending half her time worrying about the predatory aims of that mysterious 'Miss So-and-so' person down at Rollo's office.

● "As A MATTER of fact, that same wife will eventually learn to be darned glad that her husband has a good-looking and efficient 'office wife.' After all, it's rather old-fashioned to assume that there's anything between a man and his secretary, or any other feminine employee just because they both earn a living in the same shop. The two fields of mutual admiration are really so far apart. The psychiatrists might even coin a couple of new phrases such as 'marriage-love' and 'work-love' to cover two distinct and nonconflicting emotions. Everyone knows nowadays that it is physically impossible and mentally unhealthy for both parties to attempt to be completely

CAUGHT IN A TRIANGLE

tion is as acute these days as it used to be and, frankly, one reason I think so is that pictures have shown both men and women so many true-to-life situations and how to meet them that people are beginning to profit subconsciously from the examples set them.

● "THERE'S NO QUESTION, for example, that most modern wives are far better companions for their husbands than they were, say, thirty years ago. They go places with their men; since their so-called enfranchisement they do much the same things that used to be the sole prerogative of the males. And, therefore, they have less to fear in losing their husband's interest.

"They've gained more confidence now that they've learned to play men's games with men and they therefore no longer regard that good-looking blonde who sees their husband eight hours a day as an unscrupulous menace. There was a time when a man was undertaking a distinct family liability if he hired a looker for his office no matter how she helped his business.

"But, today, people realize that it's almost as essential for a successful business man to have an 'office-hostess' as it is to have a 'home-hostess.' I know of two or three very smart ladies who go out of their way to cultivate their husband's secretaries, when, a few years ago, it wasn't considered just right to have any social contact with a girl who worked in an office. And there is another problem. When two women get together, one at home and one at the office, in a friendly

Let's have a game of billiards, says Arline Judge to Clark, a guest at a recent party she gave. We won't tell who won

possessive. A business relationship is essentially mental and down far different channels, at that, than the relationships of the home.

"But, with all this talk of home versus office and wife versus secretary, people are prone to overlook the plight of the two kinds of office husbands. First the man behind the desk who is pleasantly aware of an attractive girl with him—and another one to whom he's devoted at home. Second, the husband of a girl who either has to or wants to work. The second husband is in precisely the same spot as the more familiar housewife and the same rules, of course, apply to him and his conduct with his wife as apply in the reversed situation.

● "IT IS THE PREDICAMENT of the first man that should bring solace to the boss with a matronly and forbidding co-worker. Van Sanford, for example, has Myrna Loy at home. Many men would never leave home under such circumstances, but the balance comes with Jean Harlow as his very efficient aide in the office. We all know that with both men and women a person can very readily tell when a member of the opposite sex is beginning to develop the telltale symptoms of a heart attack. Now what is a man, or woman, for that matter, to do? Should a man fire an efficient girl because he suspects that her feelings are not strictly fiscal? Or should a girl quit a good job because she likes it—and the boss—too well?

"As I said before, you're trying to put me on the spot

Gable Tells What Happens

by asking me to answer stuff like that. Okay! Well, here's where little Clark gets himself right off the spot. I don't know the answers any better than you do —if as well. I don't work in an office, I don't have a secretary and I'm very glad I'm an actor—especially after thinking of all the pitfalls that beset the paths of a man behind a desk. Personally, when I'm not working I prefer to be behind the butt of a good gun looking down the sights at a brunette who never heard of allure, who prefers berries to caviar and only makes a pass at man when she's mad—a Rocky Mountain Bear...."

Clark Gable started grinning again as he got back on his skates. "And now," he concluded, "I suppose you'll go home and quote me as saying I prefer Rocky Mountain Bears to Jean Harlow and Myrna Loy.... Well, in a way, maybe I do! I'm one guy that *knows* when he's outclassed!"

Yes, any minute now you'll be seeing Clark Gable and Vivien Leigh in *Gone With the Wind*. It really is finished

Because Clark Gable was hard at work in *Boom Town*, Carole Lombard came to the studio on the first anniversary of their marriage and cut the festive cake there

The M-G-M Lion is the Symbol that signifies Joy on the Screen. Miss Entertainment picks Leo to ride to victory!

THE WINNER!
METRO · GOLDWYN · MAYER

We're taking space in this magazine to tell you to keep your eye on Leo, the M-G-M Lion!

He's had the best year of his career what with grand entertainments like "Mutiny on the Bounty", "China Seas", "Broadway Melody of '36", "A Night at the Opera", "Rose Marie" and all the other great M-G-M hits! And of course there's "The Great Ziegfeld", now playing in selected cities as a road-show attraction and not to be shown otherwise this season.

But *(pardon his Southern accent)* Leo says: "You ain't seen nuthin' yet!"... On this page is just part of the happy M-G-M family of stars. Look them over. You'll find most of the screen's famed personalities and great talents on Leo's list. They will appear in the big Metro-Goldwyn-Mayer productions that are now in the making and planned for months to come.

Ask the Manager of the theatre that plays M-G-M pictures about the marvelous entertainments he is arranging to show. And when Leo roars, settle back in your seat for real enjoyment!

Norma Shearer

Joan Crawford

Greta Garbo

Clark Gable

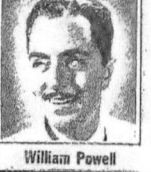
William Powell

Myrna Loy

Jeanette MacDonald

Nelson Eddy

Luise Rainer

Jean Harlow

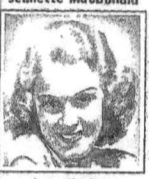
Wallace Beery

Robt. Montgomery

Eleanor Powell

Freddie Bartholomew

Robert Taylor

The Marx Brothers

WATCH FOR THEM!
Norma Shearer
Leslie Howard
 in "Romeo and Juliet"
Clark Gable
Jeanette MacDonald
 in "San Francisco"
Jean Harlow
Franchot Tone in "Suzy"
Robert Montgomery
Myrna Loy
 in "Love on the Run"
And M-G-M's Big Road Show
"THE GREAT ZIEGFELD"

Charles Laughton

Laurel & Hardy

Jackie Cooper

Lionel Barrymore

John Barrymore

Spencer Tracy

SORRY! WE DIDN'T HAVE SPACE FOR THEIR PHOTOS! MORE M-G-M STARS

Franchot Tone, Robert Young, Rosalind Russell, Frank Morgan, Edna May Oliver, Reginald Owen, Virginia Bruce, Nat Pendleton, Lewis Stone, Johnny Weissmuller, Jean Hersholt, Ted Healy, Allan Jones, Buddy Ebsen, Joseph Calleia, Maureen O'Sullivan, Una Merkel, Chester Morris, Stuart Erwin, Bruce Cabot, Elizabeth Allan, Brian Aherne, Charles Butterworth, Madge Evans, Frances Langford, Eric Linden, June Knight, Ann Loring, Robert Benchley, Jean Parker, May Robson, Mickey Rooney, James Stewart, Ernestine Schumann-Heink, Harvey Stephens, etc.

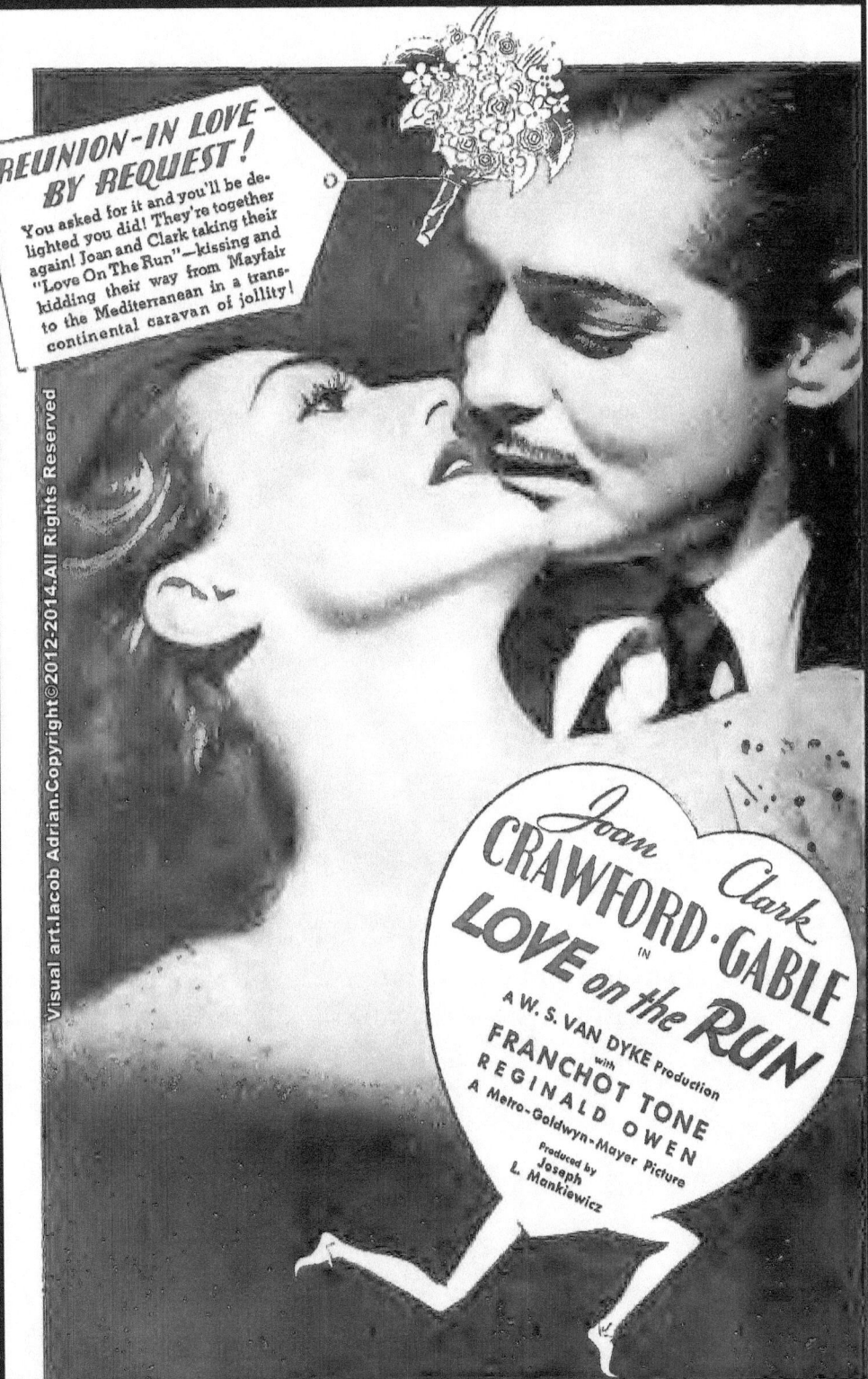

$1,000 In Cash Awards

Choose Your Favorite Star!

```
            PRIZES
         $1,000 in Cash
          64 Big Prizes
First Prize ..................... $300
Second Prize ...................  200
Third Prize ....................  100
Fourth Prize ...................   50
Fifth Prize:
   Ten Prizes of ...............   10
Sixth Prize:
   Fifty Prizes of .............    5
```

YOU STILL HAVE time to write those 20 words of special value that may win our SCREEN STAR POPULARITY CONTEST, but if you want to share in the $1,000 to be distributed in an effort to discover who deserves top rating in the screen world, your entry will have to have a postmark during March, for the contest closes April 1.

Selection of America's No. 1 film favorite is in your hands and to learn who in the minds of filmgoers heads the list ONE THOUSAND DOLLARS IN CASH will be paid. There never has been a more simple contest. All you have to do is ballot FOR THE PLAYER YOU LIKE BEST, not for the ONE YOU THINK THE MOST POPULAR. When the ballots, now pouring in and those to come, are counted, the world will know who really IS the most popular player on the screen. The final tabulation will be a true cross-section of fan reaction because the winner—man or woman—will have gained that distinction through the ballot of those who are the life blood of the box offices—the reader fans of the world.

None can foresee who will be named the top choice. It may be someone not now in the BIG NAME CLASS. The winner will be chosen on the basis of individual favor, not because of expensive advertising campaigns put behind him or her, but because the man or woman has "that something" which makes his or her work register better than any other.

The requirements for balloting are simple. Use the ballot provided for you in this magazine, NAME YOUR FAVORITE, tell in TWENTY WORDS OR LESS why you prefer your selection and then mail your ballot to SCREEN STAR POPULARITY CONTEST EDITOR, 7046-H Hollywood Blvd., Hollywood, Calif.

For example you might say: "I vote for ———— because he or she gives sincerity to every role played." Of course, that quotation cannot be used, but the most cleverly worded reason advanced by a contestant will take the capital prize of $300. The final standing of the player to which the best reason applies will have no bearing in awarding prize.

The second best reason advanced for voting someone a favorite will take the second prize of $200. The third best expression will win a $100 prize and so on down through the list until SIXTY-FOUR PRIZES have been awarded.

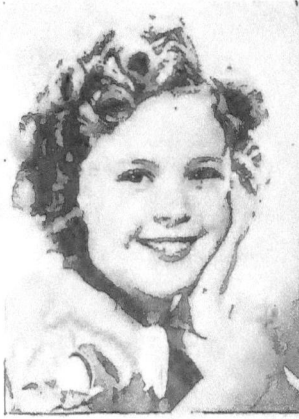

Shirley Temple

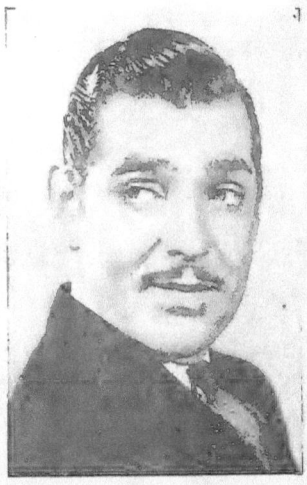

Clark Gable

Remember, elaborate entries will not enhance your chance of winning. Cleverness of expression will be the basis for judging the entries.

Read the following rules carefully, then go out to win some of this EASY MONEY. If you can give your reason for your vote in 15 words and it should win first prize it would represent $20 a word. Rather good pay for a bit of your effort. Everyone who enters will be interested to learn who is America's No. 1 screen favorite measured by the fans' yardstick. Be sure you have some part in it.

CONTEST RULES

1. To enter this contest it is only necessary to name your favorite screen player (man or woman) on the coupon published for that purpose, and tell why in twenty words, or less, you voted for this star.

2. Prizes will be awarded those contestants supplying the best and most novel reasons (in twenty words or less) for voting as they did, regardless of final standing of their choice after all votes are counted. The entry chosen as the best by the judges will receive the $300 first prize; the second best entry will receive the $200 prize, etc. In case of ties, duplicate prizes for the amount named will be awarded tying contestants.

3. Contestants may enter and thus vote for their favorite, as many times as they desire, but each entry must be printed, written or typed on a ballot coupon as published in this magazine.

4. Editors of Fawcett Publications and Motion Picture Publications are judges in this contest and their decisions shall be final. No correspondence will be entered into regarding entries in this contest. Entries will not be returned.

5. No employes of Fawcett Publications, or Motion Picture Publications, or members of their families, are eligible to compete.

6. This contest will close April 1, 1937. Entries postmarked later than that date will not be considered. Elaborate and bulky entries are discouraged. As prizes are to be awarded for reasons given for voting for your favorite screen player, your chances of winning will not be enhanced by sending in an elaborate entry.

7. After you have filled out the coupon, send it by mail to SCREEN STAR POPULARITY CONTEST, 7046-H, Hollywood Boulevard, Hollywood, Calif. You may paste your entry blank on the back of a postcard, or send it in an envelope, first class mail. It is not necessary to accompany your ballot with a letter.

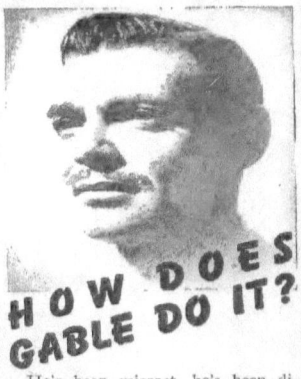

HOW DOES GABLE DO IT?

He's been miscast, he's been divorced, he's had unwelcome headlines in the press, but after nine years on the screen he's still tops! "HOW DOES GABLE DO IT?" The secret of Clark Gable's amazing success is revealed in an exclusive article in the July MOTION PICTURE Magazine.

In this same issue you'll find a beautiful colored portrait of popular MICKEY ROONEY, wonder boy of the screen. Printed on heavy paper and free of printed matter, this portrait is one you'll want to k e e p and treasure.

MOTION PICTURE
10¢ AT ALL NEWSSTANDS

MYRNA LOY
AND
CLARK GABLE

Evidently revolt-torn Ireland exemplified in *Parnell*, with Clark as the fiery patriot of Erin, was not uppermost in Myrna's mind while romancing

After No Man of Her Own was finished Carole presented Clark with a big ham with his picture firmly pasted on the wrapper

HOW WILL THE GABLE-LOMBARD ROMANCE END?

CAROLE LOMBARD, exotic, hoydenish and, in turn, very wise, won't discuss that romance which is intriguing Hollywood and everyone who is interested in motion pictures.

She has nothing to say for publication about her friendship with Clark Gable—a friendship envied by millions of women the world over.

"Why," she asks, "must all the Hollywood writers use a thousand subterfuges to interview me and then launch a barrage of questions about Clark and myself? Why can't they let us alone?"

For more than a year—ever since that fateful Valentine's party of 1936 which resulted in Carole giving Clark a battered white Ford with a big red heart on it—she has been hounded by writers. There has been a steady, clamoring procession through the white dressing room which she occupies at Paramount studio—and which she will continue to occupy for the next three years while she earns more than a million under the terms of her present contract. Each and everyone has asked:

"Why not let me have the story of your romance with Gable?"

This question has put Carole definitely "behind the eight ball." It isn't

Clark and Carole were often seen at the Paramount lunch counter during the making of No Man of Her Own

In her friendship with Clark Gable, Carole Lombard is the envy of millions of women, all of whom are wondering as to how this intriguing romance will end. This story should satisfy their curiosity!

By CECIL DEANE

fair. The writers, the public, forget that Gable, although separated from his second wife, Rhea, is still married to her, and that he says to the prying, curious ones:

"I do not at this time contemplate a divorce from Mrs. Gable."

Carole's cue is to keep silent. She, as usual, is being a perfect gentlewoman by going so far as to refuse to discuss either romance or marriage, even in an abstract way. She tells those who beg, plead, and cajole:

"Skip the marriage question. My entire attention, for the next three years, is going to be devoted to my job—making pictures—and nothing else."

AND, in that statement, is a partial answer, if not a final one, to the question as to how her romance with Gable will end.

Remember that Carole is a creature of impulse. She is spontaneous. She said that she wouldn't marry William Powell and a few days later her mother, Mrs. E. C. Peters, on May 27, 1931, announced that the wedding would take place in very short order. It did. On June 26 of that same year,

A back-stage shot of the famous stars when they were teamed in No Man of Her Own

Carole is not in favor of long engagements. She likes to have things done and over with. And that brings out one point which will be reckoned with later.

She called Powell "Junior." She played a lot of tricks on him. She had a right merry time with him. Until July 7, 1933, when her mother announced that Carole already was in Reno establishing residence. Carole was again of single status legally on the nineteenth day of the next month.

Just like that.

Again, her intimates point out, she's a creature of impulse.

It was during 1931, when she was still married to Powell, that she made *No Man of Her Own* for Paramount, with Clark Gable and Dorothy Mackaill. Clark and Carole were thrown together aplenty during the weeks it took to make that production. They were grand scouts. They ate at lunch counters in the commissary. When there was a lull in production they bought ice cream cones and ate them.

The picture was good, and people told Gable he was good. Carole presented him with a great big ham and his picture

How Will the Gable-Lombard Romance End?

was pasted on it. But neither at this time, gave any indication of falling in love.

They parted, a leading man and a leading woman who, in the course of their work, had done a good job for the studio.

In Hollywood, where a dinner engagement is construed as marital engagement, (and two dinner engagements are definite assurance that a secret marriage has taken place) there was never any talk of a lasting friendship. And you may rest assured that when Carole got her divorce there was no gossip about Gable. He just naturally didn't enter into it.

Carole clowned with "Junior."

BUT she didn't clown when and after she met serious-minded Russ Columbo, who came to an untimely end when a bullet from a gun held in the hand of a friend ricocheted from a table.

She was very serious—and a very good influence for Russ.

Russ, to us who knew him, was a shy, at times inarticulate young man who had the soul of a poet and the inspiration of a musician. He lived quietly and with great dignity. His brother, his father and mother, were the only people in his life at the time Carole met him.

She got him interested in swimming and tennis. She spent long hours with him and his parents. She brought her friends to see him. And they went everywhere together. She visited him on his sets at Universal where he was being groomed for stardom. They went to motion picture shows, which he enjoyed more than any other form of amusement.

She didn't clown. Not with Russ.

Then came that fatal holiday, when Russ stayed in town—and she went to the mountains. The word of his injury, then his death, was flashed to her. She raced to Hollywood. She found a terribly upset, distraught family. (Mrs. Columbo, quite ill to this day, doesn't know that her favorite son, Russ, is dead. She thinks he's still in Europe, making pictures.)

It was Carole who devised this tragic fiction—for Mrs. Columbo suffers from heart disease and Russ meant everything in the world to her. Carole was afraid the shock would kill her, for the elderly woman had just left the hospital herself.

Carole took charge of the funeral arrangements.

She arranged that flowers were to be delivered to Mrs. Columbo at intervals—supposedly from Russ—for many months.

AND now we go to Christmas of 1934. There was a gay party in progress in Carole's dressing room. Carole's gifts—always lavish—were being handed out by herself. Madalynne Fields, Carol's attractive and famous secretary, had a present for Carole, whom she regards with a very fine and sincere affection. It was a small gold locket. Carole opened that locket—and saw a picture of Russ Columbo. Tears started streaming down her cheeks. She turned and, without a word, went out into the dusky studio streets, walked by herself until she felt she had herself under control again.

She came back to her party.

But she wasn't clowning. It was a very subdued Carole.

And now we return to Gable, the man who worked in a picture with her and made only a very slight impression. No one in Hollywood expected to see a friendship between these two—Gable and Lombard. Just a week before St. Valentine's Day of 1936, that very wealthy Jock Whitney gave a "gag" party in the afternoon. Carole arrived in an ambulance and was carried on a stretcher into her house. That was her "gag."

Gable was present.

He and Carole had a very swell time that afternoon. And, a week later, he got the white Ford with the big red heart on it, and Hollywood started to buzz. It has been buzzing ever since. All about the big Lombard-Gable romance.

They've had a lot of fun.

There was that time they were out driving in the San Fernando Valley and got mixed up in a parade in Van Nuys. Yes, they rode right along in the parade, and had a grand and glorious time. There are those horseback rides in that same San Fernando Valley, where Carole has a ranch run by Japanese.

This last Christmas was a pretty gay time. Carole was working in *Swing High, Swing Low*, with a very good friend directing—Mitchell Leisen, who has helped her considerably in her career. Leisen and Gable are very good friends. One night, when all three were out together, Leisen said:

"There's one thing I've always wanted—a horse."

THE next day there arrived on the set a hobby horse, gift from Clark and Carole to "Mitch," as the clever director is known in Hollywood.

Just another gag—

Two weeks before Carole married William Powell, she told her closest friends:

"I think he's marvelous, but I don't think I should marry him."

Powell was free. She was free. She acted on impulse and married him.

She cannot become impulsive and marry Clark Gable. She has, in addition to legal restriction, imposed upon herself the ruling:

"I am going to think only of my career for the next three years."

Those who know Carole say that in these things lie the answer to that question everyone is asking. Her attitude toward Powell was a carefree one, a friendly sort of thing, punctuated by a great deal of fun. And it was soon washed up. In just two years. Quickly, smoothly. (When they were co-starred in My Man Godfrey they were good friends, worked well together, but were very businesslike at all times.)

Her attitude toward Gable contains many of the same elements, intimates aver. Love's a lot of fun, life's a lot of fun, and let's be gay.

"Their friendship is too light to endure," the wise ones in Hollywood say today. "It's going to die before they ever contemplate marriage."

Yes, Clark and Carole have their fun. Carole is wild about "Rhythm Girl," the mare Gable gave her. She and Clark go on picnics with Gail Patrick and Bob Cobb, with other friends. But it's all very casual, very discreet, and very dignified.

The ski is the limit says Claudette Colbert after trying to master the mysteries of this sport at Sun Valley, Idaho, during the filming of She Met Him in Paris

Carole is clowning.

Can she clown for three years more? Hollywood emphatically says she can't. The prediction, coming from the inside circles, is that there'll be a lasting and sincere friendship which will never culminate with "I do."

There are really too many factors involved.

One of them is a very, very tender memory of the time when Carole wasn't clowning—and the other is a little gold locket.

Lionel Barrymore, Clark Gable and Cliff Edwards in a scene from Saratoga, the M-G-M racetrack picture in which Gable and the late Jean Harlow are co-starred

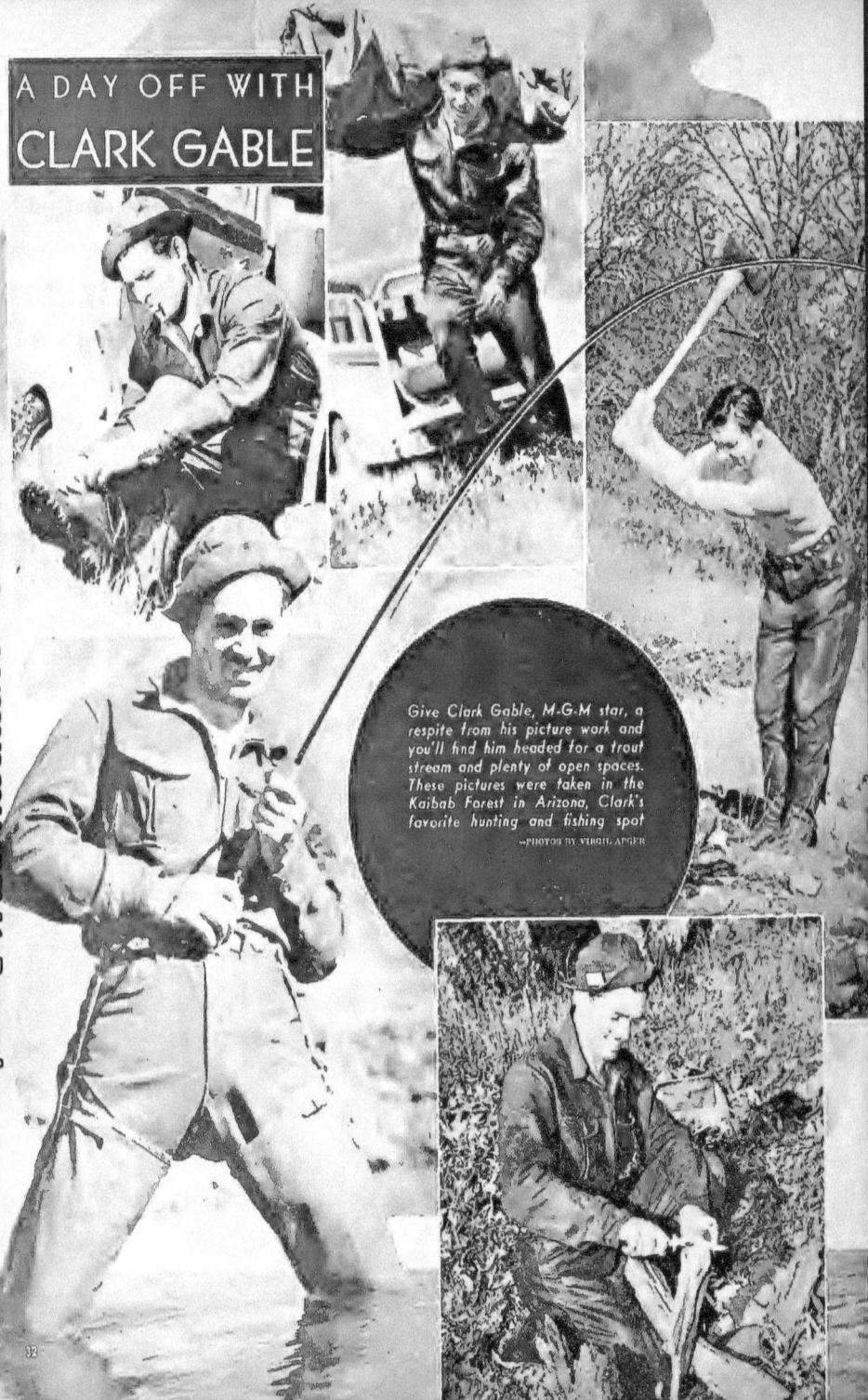

A DAY OFF WITH CLARK GABLE

Give Clark Gable, M-G-M star, a respite from his picture work and you'll find him headed for a trout stream and plenty of open spaces. These pictures were taken in the Kaibab Forest in Arizona, Clark's favorite hunting and fishing spot

—PHOTOS BY VIRGIL APGER

FASHIONS for MEN

Hugh Daniels, studio stylist, who knows when Hollywood stars are properly garbed for all occasions says that—

1. He (Clark Gable) is the epitome of smartness in sports jackets and slack combinations, and has the reputation of wearing th's type garb with more distinction than any star of the screen.
2. He (Ralph Bellamy) always chooses the proper handkerchief for his sport shirts, harmonizing pattern and color effectively.
3. He (Fred Astaire), considered one of America's best dressed men, not only wears the proper tie for all occasions but is one of the few men who knows how to tie them properly.
4. He (Bert Wheeler) selects always the hat which will be most suitable for his outfit and takes care that it a so is correct y proportioned for his small stature.
5. He (Preston Foster) always looks exceptionally well in tails. Unlike most men he always wears gloves to top his formal evening wear.

. .

SUMMER HIGHLIGHTS

1. Light tan laces in dark brown shoes.
2. Bold patterned neckwear handblocked on white foulard.
3. Cocoanut hats with pugaree band, handwoven in Nassau, smart with rough tweed sport jackets.

CLARK GABLE is a pace-maker in sports wear. He is here shown wearing a pair of heavy tweed slacks, a zipper gazelle jacket (Note epaulets on shoulders) and natural linen sport shirt

BERT WHEELER prefers a lightweight tan gabardine suit for warmer days. His tie and shirt are both of striped madras. His Knox hat of light weight has a snap brim and is proportioned perfectly to his small stature

FRED ASTAIRE injects his personality into his clothes. Note his hand-loomed vicuna jacket, white Oxford shirt with buttoned down collar, spitalfield tie, English foulard sport kerchief in pocket and his perfectly tied tie

PRESTON FOSTER'S dress suit is made of light weight midnight blue barathea and his hat is of light-weight grosgrain. His linen shirt, linen collar, pique tie and waistcoat complete the ensemble

RALPH BELLAMY wears a very smart gabardine sport shirt with polka dot 'kerchief at the throat

Hollywood photos by Bachrach, Miehle, Schafer and Bull

Bachelor Bob Taylor never entertains in the customary Hollywood sense

THE GAY LIFE OF HOLLYWOOD BACHELORS

By LEON SURMELIAN

equipment mean more to Clark than all the swimming pools and electric gadgets of Beverly Hills.

His suite in the hotel consists of two rooms, a living room and a bedroom. There is nothing swanky about them. He has a wardrobe man who goes to the hotel twice a week to see that his clothes are pressed, his shoes shined. He has no

Bachelor Bill Powell's idea of heaven on earth is to lie in bed all day and read

Bachelor Clark Gable's idea of a party is to talk and play cards with two or three couples in the home of a friend

HOLLYWOOD bachelors—how do they live? We mean guys like Clark Gable, Bob Taylor, Bill Powell, Jimmy Stewart, Tyrone Power, Michael Whalen, Eric Linden, Tom Brown. What are the real private lives of these foot-loose and fancy free gentlemen of the romantic brigade, without benefit of ballyhoo?

Gable—still legally married, to be sure, but currently the No. 1 bachelor—lives in a hotel. He is a wanderer and outdoor man by nature, and home and property don't mean very much to him. "I like to live under my hat," he told us. "My Hollywood mansion is my station wagon." Hunting and fishing

The Gay Life of Hollywood Bachelors

secretary, no servants. "I eat out all the time. For breakfast, usually I have a baked apple, cereal, coffee and toast. For lunch, a sandwich or two, maybe a salad. But I go to town for dinner. I have no favorite place to eat. When I am working, I lunch at the studio commissary."

You never see Clark Gable in Hollywood's celebrated night clubs, and he doesn't care to dance. "My idea of a swell Saturday night party is to talk and play cards with two or three couples in the home of a friend." He never entertains. Sometimes he takes a few people out to dinner, that's all.

Bob Taylor lives in a small, one-story house on a quiet street in Beverly Hills. He has a Hungarian servant, Joe. There is absolutely nothing about this place to indicate that a movie star lives there except the long arrays of suits in the closets and the stacks of freshly laundered shirts which Joe has a habit of piling up on beds and dressers. The living room, with its radio, books, fireplace and tricky little bar is such as any successful bachelor living alone might have. He sleeps in a small bedroom, almost austere in its simplicity. There is a guest room, a small gymnasium, bathroom and kitchen, all neat and spotless, but innocent of the arts of professional interior decoration. "I've taken another year's lease on this house," Bob said proudly. "I like it."

Bob loves to dance, anywhere where there is a good orchestra. He never entertains in the customary Hollywood sense. Now and then he takes a few friends to the Beverly Wilshire Hotel for a dinner dance.

BILL POWELL gave up his famous palazzo in an ultra-ultra section of the movie colony, apparently because he was tired of living like a lone emperor. His present house, a good-sized one, but far from being a palace, is located in the comparatively plebeian atmosphere of West Los Angeles. Instead of holding open house, he holds open court—for tennis players. He likes to entertain informally. He has a barbecue pit, and after the feast runs off a picture in his projection room.

"I'd rather have my friends come to my house than go out myself," he said.

Bill Powell has devoured a good-sized library. His idea of heaven on earth is to rest in bed all day and read. "I'm terribly lazy. If I ever build a swimming pool again, I'll have a moat dug around my house and swim round and round without the necessity of turning back after a few strokes. I think I'll also have a drawbridge."

James Stewart lives in Beverly Hills, with Joshua Logan and John Swope, two young men who are interested in the directorial and production end of motion pictures. A fourth member of this gang was Henry Fonda, now sane and married. "We had a swell house in Brentwood," Jimmy said, "but when Fonda got married we moved to a much smaller place and kept looking for another house. We had to wait another month before we found a house we liked.

"Before I came out here," continued Jimmy, "I had an idea that this was a wild town of Babylonian whoopee parties, that nobody came out of Hollywood unsinged, that by signing a movie contract you signed your death warrant, and all that stuff. Who gives those whoopee parties, I'd like to know! Why, this is the quietest town I have ever lived in, and I have never met so many nice, well-behaved people in my life."

Jimmy would like to marry and build a home of his own, "on a hill," as he explained. Remember that he studied architecture at Princeton. We were curious to know why he doesn't have a steady girl, why he steps out now with Eleanor Powell, now with Ginger Rogers or Virginia Bruce, and keeps the movie snoopers guessing. The color deepened in his cheeks. "I'm wondering, myself, why I don't have a special girl! In college, I usually went to the proms stag. I used to take girls to proms and house parties, but for some reason or other they were always whisked away from me." Jimmy doesn't seem to realize how popular he really is with the lovely peaches of Beverly Hills.

THE other day we lunched with Tyrone Power at the 20th-Century-Fox Studio. This slender, patrician six-footer with glittering dark eyes is a vital and vibrant chap, full of the joy of life, and are the gals crazy about him.

"I live with my mother in a little house," he said. "Our house isn't large enough to accommodate a lot of people, so I give only small dinner parties, or more often, go outside. I stay in two nights a week, to write letters and attend to business affairs. When I'm not working I like to go to Palm Springs. My hobbies are tennis, bowling and swimming. Most of my friends are non-professionals."

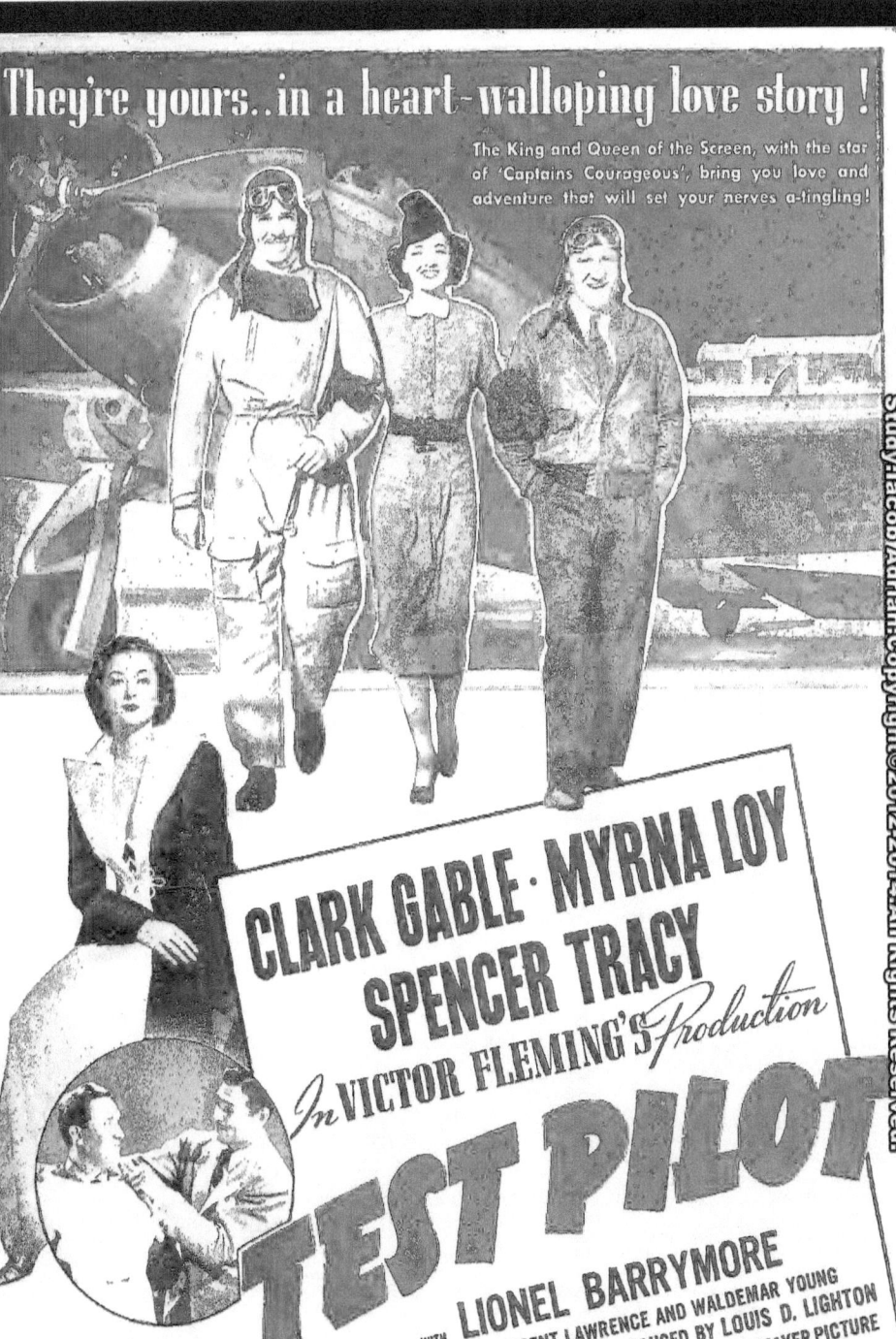

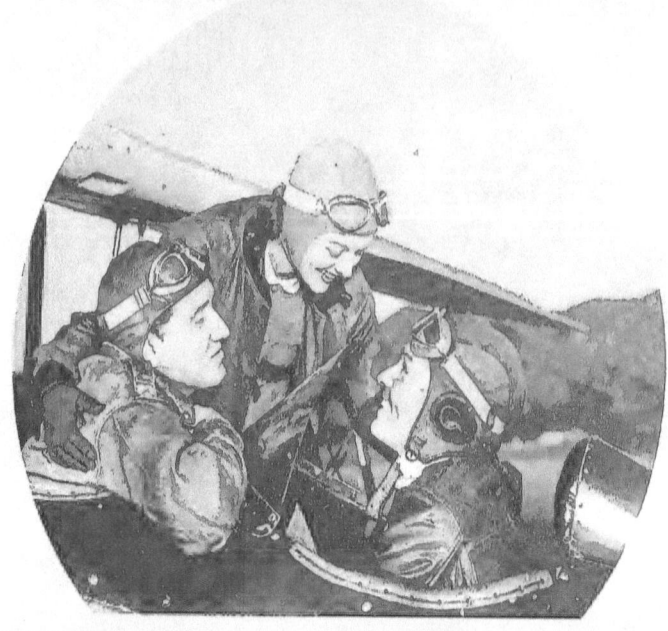

IT TAKES THREE TO MAKE A LOVE AFFAIR

Above are the three who make the love affair in *Test Pilot*, soon to be released

"It takes three," remarked Myrna Loy, "to make a love affair."

She tipped her pretty auburn head upward in the captivating Loy manner and let a quizzical sparkle slide into her gray-green eyes. Yet she meant what she said. Her tone was serious.

"When a girl isn't truly in love with John Doe, she finds that out after meeting John Roe," said Myrna, "but when a girl's truly in love with John Doe, even a temporary infatuation for John Roe only makes her realize how much she loves the first one. I've watched it work out in the case of some acquaintances. Not that I recommend the method—it's too chancey!

"Just the same, a modern woman ought to look twice before she leaps—into matrimony. Oh, it certainly takes three to make a love affair; the third one's for comparison, for making up her mind. Rather often he turns out to be the man she marries after all."

It is from the dilemmas and tribulations of a large circle of friends that Myrna has deduced the need of a third party to the average courtship and from her observations she has drawn a number of shrewd conclusions. She smiled, recalled them, as she lounged in her buff and green dressing room at the M-G-M studios.

Everybody has heard about the course of true love seldom running smoothly, but Myrna Loy introduces a note of reassurance, by saying that rough going is all to the good in the happy ending

By
JESSIE HENDERSON

That girl with a temporary infatuation for John Roe, of whom Myrna had spoken, went absolutely haywire for a month over this handsome stranger who cut in at a dance on her fiance, John Doe. Still engaged to Doe, she dashed around with the new lad like one bewitched while the whole town, diverted and scandalized, argued as to the outcome. She swam with the new heart interest, rode with him, gazed earnestly into his dark eyes, even tried to learn to cook his favorite dishes ("An almost fatal symptom!" Myrna commented.), until, all of a sudden—pfft! She realized in a flash that this wasn't the real thing and galloped madly back to her first love. They've been happily married now for five years. The point is, she might never have married Doe, at least she probably wouldn't have settled down to a contented wedded life with him, except that by comparing him with the scintillant Roe she discovered the difference. Roe's glitter was tinsel and Doe's quieter gleam was pure gold.

Wise, and sweet, is the philosophy Myrna has evolved from the things she's seen others do along these lines, or neglect to do. That aristocratic, somewhat Mona Lisa smile of hers, deepened at various recollections. Cool and poised as she always seems to be—cooler than ever in the smart green tweed frock—her strongest characteristic is nevertheless a keen sense of humor. She says you need a sense of humor most when you have it least; that is, when you're in love.

"Comparison!" she insisted, "not jealousy!"

In other words, she went on to explain, if the man you love goes out with another girl, don't grow jealous. Instead, remind yourself: "Well, I compare favorably with her," and see to it that you do compare favorably with her by not flying into a tantrum. This getting jealous is a lack of self respect, an inferiority complex.

But if you can't help feeling jealous, in other words if

It Takes Three to Make a Love Affair

You insist on considering yourself less alluring than the girl he's taken out for an evening, at least don't be catty. Myrna doesn't believe in catty-ness under any circumstances. "Be bigger than the situation," she advised with a sage wag of that auburn head, "or else you give him the chance to say, 'Ho, ho, I was right. The second girl *is* nicer.'"

In a three-cornered crisis of this sort, she proceeded, when the man of your heart shows a right interest in somebody else, the big thing is not to make any phony gestures. For instance, don't say, "She's such a dear; too bad she's bow-legged." A man—yes, even a man—catches on to that kind of sabotage after a while. No, the thing to do is to do nothing. This is one of the hardest things in the world to do, and one of the most effective. Take competition as a challenge. Perhaps the other girl is nice, and it's up to you to be nicer. Anyhow, in getting jealous you simply hurt yourself and oftener than not help your rival.

A mousey, diffident little girl whom Myrna knew about went into a fury of despair and indignation because her boy friend took another girl to a dance. Admittedly, it was a rather funny thing for him to do, but he did it. Feeling that right was on her side, she wasted no time when she met him on the street next day but immediately plunged into a hot argument during which her voice grew louder and higher. All mouseyness, all diffidence, fled.

She embarrassed the man. As she saw people pause in astonishment, she embarrassed herself. Abruptly she stopped in mid sentence, but too late. "There!" she ended angrily, on a more subdued note, "I've never made a scene in public before. It's all your fault—I hope that'll teach you something."

"It's taught me several things," replied the man who had first admired her for her appealing little-mouse quality. Among other things it taught him that, as his wife, the girl might unexpectedly make him ridiculous in public or miserable in private. He dropped her as if she'd been a hot brick.

No, even under the most trying circumstances of this kind, the thing to do (Myrna was repeating) is to do nothing. And if you're very, very clever, you not only do nothing; you say nothing. That's the hardest, and cleverest move of all. Let the one who has made the mistake and gone away be the first to come back. For, look: If the situation doesn't eventually smooth out, then—since the erring one's affection wasn't any stronger than that—it's a good thing the break came when it did. Under those conditions, it couldn't come too soon.

"When such a situation arises," Myrna added, "when the man begins taking another girl around, the strain generally brings out the first girl's worst qualities. At the very time when she should be at her best! She ought to put the situation in the bottom drawer and leave it there till the whole thing's finished, one way or another; not keep dragging it forth to display to her friends or to weep over in secret."

You must take these things, Myrna believes, philosophically. Though you don't realize it at the time, it is probably nature's way of working things out. Often the damsel who wept and wailed over her delinquent boy friend has found—rather promptly, too—another boy with whom she could be happier than she'd ever have been with the first.

Take, for example, the maiden who languished because the man of her choice ever so often fell in love with a new face. Fundamentally, he assured her, he didn't absolutely love any of these lesser beauties but he hated to be tied down to one girl friend all the time. The maiden reasoned, and her reasoning was good, that if he cared a lot about her he wouldn't flitter here and there with others; even if he did come back to her when the new interests began to pall.

One evening, abandoned in somewhat cavalier manner at a night club for a long hour while the gay Lothario tentatively flirted with a new blonde on the terrace, the maiden suddenly murmured an excuse to the rest of the party, wrapped her cloak about her shoulders, and marched to the door to summon a taxi. She was going home. She was through. But at the doorway she ran plump into a young man so mad he gibbered when he tried to speak. She recognized him as the erstwhile escort of her own Lothario's new blonde. Misery loves company. The two jilted ones joined forces, adjourned to another night club to discuss their grievances, and found that they both liked the old-fashioned waltz and roast wienies.

They both liked dependability, too. Consequently, each was dependable. Therefore they married each other. But in each case it had taken a third person to help on the decision.

This anecdote has a sequel. The dependable one didn't roam from his own fireside, but he had a temper. Still, his wife had a sense of humor. One breakfast he grew so annoyed about a telephone message from the office that he threw his (empty) coffee cup across the room. Not at his wife, but at the wall.

Did friend wife rush out to see her lawyer? Not she; for, as Myrna points out, love—when you come down to brass tacks—can stand practically anything but disloyalty. If more wives—and husbands—would remember this and summon a sense of humor before an emergency grew into a crash, there'd be fewer decisions in Reno.

When the husband stamped out of the house, so mad he forgot the goodbye kiss, this wife didn't feel that All Was Over. She collected the coffee cup. That evening at dinner when she brought in the coffee pot she put a gleaming china cup at her own place and a jagged fragment of hubby's morning coffee cup, balanced delicately upon a saucer, at his. Hubby burst out laughing, and the incident was closed.

Myrna thought this coffee cup diplomacy was about the best she'd ever heard. For Myrna, despite her pronounced femininity—notice those little hands making graceful gestures while she talks—has a man's viewpoint, and that's a rare thing in woman. She knows, for illustration, how to drop small discussions, small plans, small differences of opinion, without making a fuss about them; knows this better than any other woman I've ever met. It takes a matter of major importance to make her grow serious to the extent of insistence. And, incidentally, when she does battle for a thing she considers important she does so with calmness and good taste.

In short, Myrna's convinced that the great life-saver for engagements, and for marriages, is appreciation of what you have. Don't get so used to love that you slight it. Getting used to love and slighting it is why marriages have a "ten-year lull," why they slump into the commonplace within ten years, and often sooner.

The girl who went into an ecstasy of appreciation when her fiance brought half a dozen roses is the same girl who doesn't even say, "Thank you" when the same man after ten years of marriage lets her put a fur coat on the charge account for which he foots the bills. On the other hand, the fiance who brought roses may be the same man who never dreams of bringing home even a bunch of dandelions now. It works both ways.

"A man likes the little, sweet attentions," Myrna said, "the things you did that made him think you were sweet when you first met him; the things that attracted him at the beginning. Keep them up!"

It's a couple of days before the wedding. Your fiance drops by to remark modestly: "I went around the course in 80 today." You leap to your feet, palpitant with admiration, kiss him soundly, and exclaim in accents of awed enthusiasm: "Dar-ling! How won-derful!!"

Oh, sweet little woman! Who wouldn't marry you, you pet?

Okay. It's ten years later. Husband comes home, beaming, "I broke 80 today," he brags. You're reading a book. "So what?" you snap. All right, all right, Sourpuss; but if this were ten years ago there wouldn't have been any wedding bells.

Well, that same evening, while you're dining with friends, your husband says to their house guest. "I broke 80 today." "Really?" she squeals. "How won-derful!!"

And pretty soon your friends begin to hint how your husband and that redheaded snip appear to get along very nicely together and so on and so on and so on. It takes three to show two where they stand.

See? See what Myrna means?

CLARK GABLE
"TOO HOT TO HANDLE"
MYRNA LOY

The best news since "Test Pilot" with that rare pair of romancers, M-G-M's tantalizing twosome. Clark's a daredevil newsreel man—Myrna's an airdevil aviatrix...Action! Heart-pumping paradise for thrill and fun-loving picture fans!

with WALTER PIDGEON · WALTER CONNOLLY
LEO CARRILLO · Screen Play by John Lee Mahin and Laurence Stallings
Directed by Jack Conway · Produced by Lawrence Weingarten · A Metro-Goldwyn-Mayer Picture

Report On Cuba

Fascinating were the experiences of a reader of HOLLYWOOD Magazine when she went to the movies in Cuba.

You call him Clark Gable, but he is known as Clarkey Gobbley to hundreds of enthusiastic fans

Believe it or not, this is Hinher Rohers, and the gentleman on the right is known as Robairto Teelor to many adoring maidens in the South

Dear HOLLYWOOD Editor:

I have just returned from my first trip to Cuba—not the Cuba of Havana with its smart shops and hotels and sophisticated inhabitants. But the small towns of eastern Cuba, where life is less cosmopolitan and the inhabitants, just as charming, are simpler. It was there I learned something I thought might be of interest to you and to other readers of HOLLYWOOD the fact that Cubans love American movies.

I love movies myself. Most of my friends are ardent fans. But our interest pales into positive indifference compared with the passion of our Cuban friends. I have never seen anything like it. When a Cuban hates he hates, and when he loves he loves. And there is no doubt that they love movies with all the fire, the violence, and the single-heartedness of the Latin temperament.

I learned this the first day. I was sitting in the lobby of a small hotel, waiting for my father. A movie magazine was open on my lap but I wasn't reading. I was looking instead out on the dusty, sunny street, with its palm trees and great colorful flowers and its low-voiced, slowly-moving passersby. It was a different world from any I had ever known.

Suddenly a girl sat down on the couch beside me. She was about seventeen, shy, and very lovely with her olive skin and dark eyes. She pointed to the magazine in my lap.

"You like Clarkey Gobbley, si?" she asked eagerly.

"I beg your pardon?"

"Clarkey Gobbley. You like him, si?"

I was baffled. Then shyly, but still eagerly, she pointed to the picture on the page in my lap. Of course! Although many of the younger Cubans speak and read English, they still pronounce our proper names in Spanish. Who else could Clarkey Gobbley be but—Clark Gable!

"Oh, yes!" I said. "I mean—si! Do you?"

What a torrent of praise I had called forth! She chattered in Spanish and in English, she rolled her eyes ecstatically. And she threw questions at me faster than I could answer. Was not Clarkey muy bueno? And what of Robairto Teelor? She paused expectantly—and for breath.

Yes, I liked Robert Taylor. And Hoan Crawford? And so-beautiful Hinher Rohers?

The last one had me stumped until I had time to translate. Ginger Rogers, of course. Oh, yes, I was particularly fond of Ginger. On and on the senorita chattered, asking hundreds of questions, most of which I could not answer. We talked movies until my father came. And after that, we were fast friends the whole time I stayed at the hotel, and all we ever talked about—or rather, all I was ever talked to about—was movies.

It dawned on me after I had talked with her, and with other young Cubans, that to them movies are not acting but real. This was illustrated in an amusing way once when my father and I were talking to a group of Cubans.

The name of Charlie Po came up. When we looked a little blank, they were obviously disgusted with our ignorance. Why, they said, he is the greatest detective the world has ever known. He is a Chino (Chinaman) but he travels all over the globe and no one who has ever lived can do the miraculous things he has done. Beside him our English detective, Sherlock Holmes, is a bobo (fool), I then had a brainstorm and said, "Oh, you must mean Charlie Chan."

Si, si, only they call him Charlie Po. Why this is I never discovered, but they were loud in their praise and declared that if ever Cuba had a murder mystery they hoped the Cuban government would send for Charlie Po at once to solve it.

Movies are so real to them that whenever a Clarkey Gobbley or Robairto Teelor picture is shown, the senoritas dress in their finest and fall all over themselves to get front row seats. Much as our mothers, I suppose, sat on the front row of the legitimate theatre in hopes that the matinee idol of their day might notice them.

They love Chiquita Shearley Templey, too. To them she is *la mas simpática que todas* (the most winsome little girl of all). *Platinos* (blondes) are more popular than brunettes, and Mae West is a great favorite. *Mequilito Musey* (Mickey Mouse) is the most popular comic strip, and at westerns and gangster pictures they get so excited that the noise they make can, literally, be heard for blocks.

Once when I was in one of the smaller towns I noticed a sign in front of the movie theatre that announced in big letters, "Ginger Rogers in person, SOON!" I got quite excited because I had known Ginger as a little girl in Fort Worth and I wanted to see her again.

So I went to the manager to find out when she was to arrive. He told me with eloquent, sad gestures that unfortunately the beautiful *platino* was kept in the States this time, but that she would certainly arrive at a later date. After that, from time to time whenever one of Ginger's pictures was to be shown, the sign would appear again. Of course she never arrived. But the manager always had a valid excuse and I discovered that, neither in his own mind nor in the minds of his ardent customers, was he doing anything dishonest. Seeing Ginger on the screen was just like seeing her in person, to them, and they were just as enthusiastic as if she had appeared in flesh and blood.

One of the last evenings I was on the island I went to a G-man picture with my father. It was Saturday night, and the house was packed. The townspeople all came, as well as the farmers and workmen from surrounding plantations in town for the day, with their wives and children. It was a colorful audience. You saw, occasionally, a woman in a *mantilla*, now seldom worn, or a young girl with flowers in her hair. Some of the men from the country wore *machetes* (a short, sharp sword-like knife). The flow of their soft voices was like music, with here and there a staccato note. The place was alive with voices before the picture started, but even when the lights dimmed and the title was thrown on the screen they didn't stop talking. They simply changed the subject of conversation. They began talking to the characters in the picture, or about them. It was shown, as nearly all American pictures are, with English sound and Spanish sub-titles.

The G-men they greeted with enthusiastic shouts and cheers. The villainous gangsters they greeted with cries of "*Quite se!*" Which is the Spanish equivalent of "Take it away!" When one of the G-men was killed, the man next to

me sighed and said "*Que va!*" That means in literal translation, "What goes," but figuratively it is an expression of resignation like, "Well, that's the way life is."

At the climax when the G-men were closing in on the hide-out and the machine guns were blasting and the tear-gas bombs thrown, they stood up and yelled. It was all terribly exciting and noisy, and when I came out I thought—and I'm afraid in quite a superior sort of way—"How quaint the Cubans are, after all, to get so excited at a movie!"

Last week, on Saturday night, I went to a movie in my own home town, right here in the States. It was, as it happened, another G-man picture. The house was packed with townspeople and the farmers in town for the day with their wives and children. It was an exciting picture and I was quite carried away with it. And then all of a sudden, right at the climax, I was aware of what was going on around me. The place was a bedlam. There were shouts and cheers and stamping of feet; there were cries of "Go get him!"

And I thought, a little shamefaced but with a great thrill, that movie audiences are not very different, no matter where you find them.

Vive cinema!

Sincerely yours,

HELEN IRWIN DOWDEY

HOW DOES GABLE DO IT?

He's been miscast, he's been divorced, he's had unwelcome headlines in the press, but after nine years on the screen he's still tops! "HOW DOES GABLE DO IT?" The secret of Clark Gable's amazing success is revealed in an exclusive article in the July MOTION PICTURE Magazine.

In this same issue you'll find a beautiful colored portrait of popular MICKEY ROONEY, wonder boy of the screen. Printed on heavy paper and free of printed matter, this portrait is one you'll want to keep and treasure.

MOTION PICTURE
10¢ AT ALL NEWSSTANDS

Gable did not kiss

That Scarlett Woman

Leslie Howard discusses the famous heroine of *Gone With the Wind* and decides that she is very much like many of the girls of today!

By JESSIE HENDERSON

"But what people seem to overlook is that Scarlett was so *modern!*" said Leslie Howard, rigged out nattily (according to the year 1861) in the habiliments of Ashley Wilkes for the opening sequences of that *Gone With the Wind* picture; "Scarlett O'Hara was a new-fashioned girl in an old-fashioned setting. She was a 1939 sub-deb.... in hoopskirts."

As he spoke, Scarlett herself tripped daintily across the lawn in hoopskirts of pale green silk, her dark little head tilted at a proud slant. The lawn was in Busch Gardens, Pasadena, where the Selznick company was on location for this picnic-barbecue scene at Twelve Oaks, the Wilkes estate. And Scarlett, of course, was Vivien Leigh, the bright-eyed English actress who so nimbly exchanged her London accent for the soft dialect of Georgia.

In his character of Ashley, Leslie Howard had just declined as courteously as possible Scarlett's offer of marriage; explained that he loved Melanie Hamilton (Olivia de Havilland) whom he was soon to marry. The tempestuous tete-a-tete had taken place in the library of the Wilkes mansion, a portico of which could be glimpsed among the tall trees. Howard, collapsing in a chair outside his portable trailer dressing room, loosened his high collar and stock. Refusing Scarlett anything involved quite a strain!

"Possibly my idea of Scarlett differs from that of some people," Howard conceded. His cultivated voice formed a musical undercurrent to the yells of prop boys and the harsh directions that boomed from time to time through the loud-speaker system. "But I've studied her carefully.

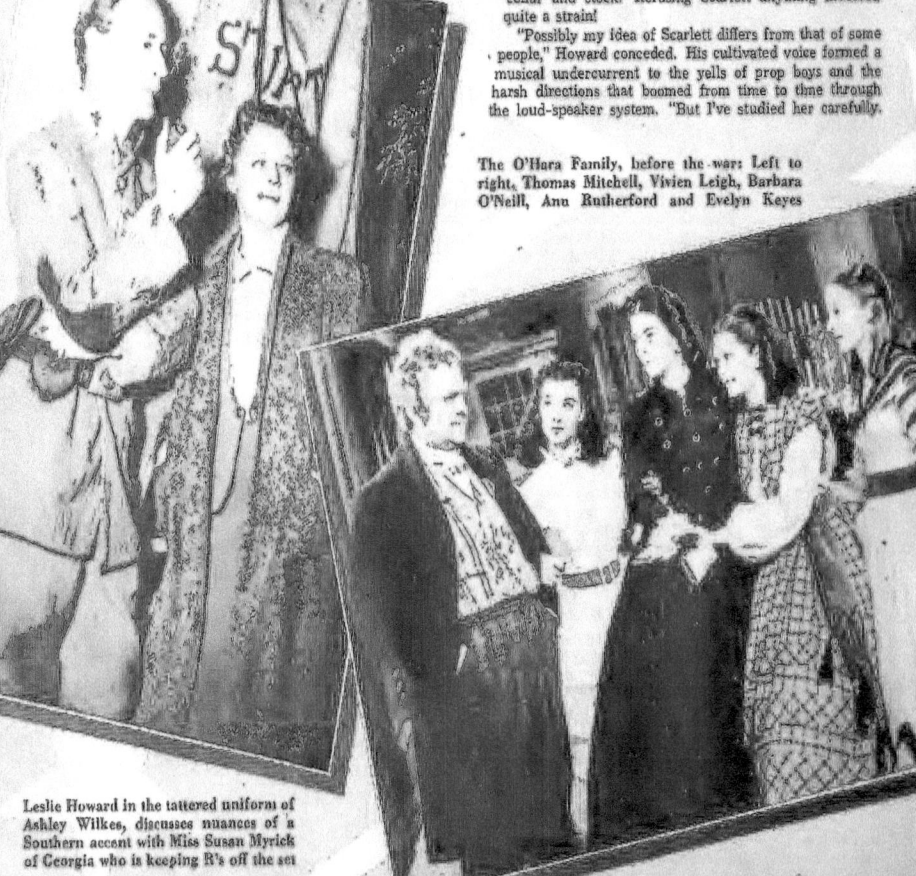

The O'Hara Family, before the war: Left to right, Thomas Mitchell, Vivien Leigh, Barbara O'Neill, Ann Rutherford and Evelyn Keyes

Leslie Howard in the tattered uniform of Ashley Wilkes, discusses nuances of a Southern accent with Miss Susan Myrick of Georgia who is keeping R's off the set

Olivia de Havilland, as the gentle Melanie, gets a final touch-up from Hazel Rogers

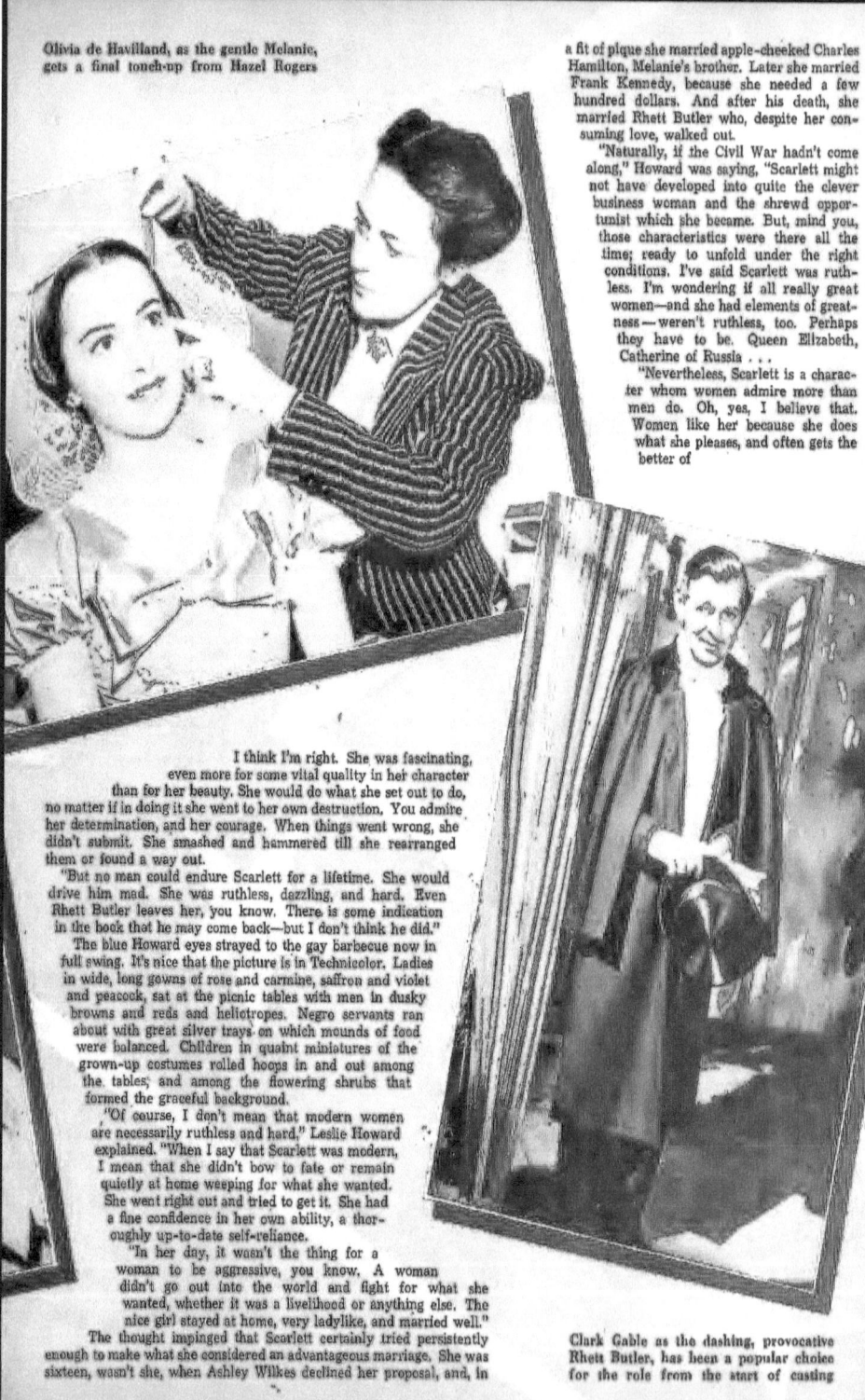

a fit of pique she married apple-cheeked Charles Hamilton, Melanie's brother. Later she married Frank Kennedy, because she needed a few hundred dollars. And after his death, she married Rhett Butler who, despite her consuming love, walked out.

"Naturally, if the Civil War hadn't come along," Howard was saying, "Scarlett might not have developed into quite the clever business woman and the shrewd opportunist which she became. But, mind you, those characteristics were there all the time; ready to unfold under the right conditions. I've said Scarlett was ruthless. I'm wondering if all really great women—and she had elements of greatness—weren't ruthless, too. Perhaps they have to be. Queen Elizabeth, Catherine of Russia . . .

"Nevertheless, Scarlett is a character whom women admire more than men do. Oh, yes, I believe that. Women like her because she does what she pleases, and often gets the better of

I think I'm right. She was fascinating, even more for some vital quality in her character than for her beauty. She would do what she set out to do, no matter if in doing it she went to her own destruction. You admire her determination, and her courage. When things went wrong, she didn't submit. She smashed and hammered till she rearranged them or found a way out.

"But no man could endure Scarlett for a lifetime. She would drive him mad. She was ruthless, dazzling, and hard. Even Rhett Butler leaves her, you know. There is some indication in the book that he may come back—but I don't think he did."

The blue Howard eyes strayed to the gay barbecue now in full swing. It's nice that the picture is in Technicolor. Ladies in wide, long gowns of rose and carmine, saffron and violet and peacock, sat at the picnic tables with men in dusky browns and reds and heliotropes. Negro servants ran about with great silver trays on which mounds of food were balanced. Children in quaint miniatures of the grown-up costumes rolled hoops in and out among the tables; and among the flowering shrubs that formed the graceful background.

"Of course, I don't mean that modern women are necessarily ruthless and hard," Leslie Howard explained. "When I say that Scarlett was modern, I mean that she didn't bow to fate or remain quietly at home weeping for what she wanted. She went right out and tried to get it. She had a fine confidence in her own ability, a thoroughly up-to-date self-reliance.

"In her day, it wasn't the thing for a woman to be aggressive, you know. A woman didn't go out into the world and fight for what she wanted, whether it was a livelihood or anything else. The nice girl stayed at home, very ladylike, and married well."

The thought impinged that Scarlett certainly tried persistently enough to make what she considered an advantageous marriage. She was sixteen, wasn't she, when Ashley Wilkes declined her proposal, and, in

Clark Gable as the dashing, provocative Rhett Butler, has been a popular choice for the role from the start of casting

That Scarlett Woman

men in a battle of wits." He gave his sudden smile. "This doesn't please men so much."

At that instant from one of the trailer dressing rooms stepped a figure in black and brown, with sideburns and an 1863 hair-do. He turned out to be the Rhett Butler of the piece—Clark Gable. "Hi-yo, Silver!" Gable cried with an ebullience rather refreshing amid the surrounding ante bellum formality.

"Be right with you!" Howard answered, and with his knuckles he began to evoke the sound of galloping hoofs from the seat of a chair.

But before Gable spoke further, Vivien Leigh came tripping back across the greensward with Olivia de Havilland. Director Victor Fleming shouted an order. And, presto! Before you could say, "Atlanta, Jawgyuh," the action moved to the interior of Twelve Oaks.

This house was a little more elaborate than Tara, the home of Scarlett; though Tara was, you may be sure, no shack. For one thing, Twelve Oaks had a huge dining room, of the proportions demanded by Southern hospitality, and on its carved serving tables there stood—flashing in the sun from the long windows—quantities of antique silver plate, every item a collector's piece.

Twelve Oaks, moreover, had a lightly curving and wholly magnificent double stairway; a marvel of architecture, springing from the hall in a stately flight of steps, to divide at the landing as it soared to the upper floors. Along the stair wall hung $6,000 worth of paintings, which, with the silver, were closely guarded while the film was in production. Mounting the stair, you found, off the upper corridor, a bedroom with a lofty ceiling and an enormous four-poster bed. On the bed and on sofas, twenty-four girls (shedding their five-foot hoop skirts) took an afternoon nap following the barbecue, while the gentlemen smoked, wined, and talked downstairs.

It was from this bedroom, and down this stairway, that Scarlett had stolen while the other girls slept, to propose marriage to Ashley. With the strange, higgledy-piggledy movie methods which come out all right in the end, the proposal scene had already been shot before the start of the barbecue which, in the plot, precedes it. But before they could shoot another scene in the library, they had to clean up the fireplace. It was full of broken china.

At the conclusion of the touching and tense love sequence—the love, alas, being all on Scarlett's side—Ashley had in embarrassment and pity left Scarlett in the library. When the door closed, she snatched a costly Limoges vase, and with all her strength dashed it on the hearth. To her consternation, at the sound of the crash a man rose from the big chair in which he'd been an unintentional eavesdropper. Rhett Butler! He'd heard everything! Scarlett glared as if she could have murdered him. It's a wonder, come right down to it, that she didn't.

■ With the china swept up, however, and another library interior taken—this time with ladies and gentlemen saying goodbye and what a nice time and do drop over to see us soon—the entire company scampered to another spot where stood the "bazaar" set. Yes, the Atlanta ladies were holding a bazaar to raise money for the wounded Confederate soldiers.

The scene was a perfect glory of color. It contained bright flags (Confederate, of co'se); the yellow, blue, red and green uniforms of Confederate officers who belonged to various outfits such as the Louisiana Zouaves and the (Confederate) President's Guards; the red shirts of the Atlanta Fire Department, a swanky volunteer organization of socialites; and the ladies' silk and velvet gowns. The fashionable feminine colors that year were emerald, magenta, puce, turquoise, gamboge and aquamarine. To decorate the walls and booths, the studio cornered the Hollywood supply of smilax.

In dramatic contrast with the brilliant dresses about her, Scarlett appeared in the black, enveloping widow's veil which she wore for Charles Hamilton, though she detested it. Scarlett O'Hara, according to Margaret Mitchell's book, had both French and Irish blood. Her jaw was square but her chin pointed; her eyes were green as jade, her thick, black lashes curled upward and her thick, black brows slanted up at the outer ends. Her skin was the flawless magnolia white so prized by Southern women, her hair was dark, and her waist (thanks partly to tight lacing) measured seventeen inches.

To a remarkable extent, Vivien Leigh's features answer this description. As she prettily coaxed bazaar patrons to buy this and that useless gewgaw, she was Scarlett to the life. It took Margaret Mitchell seven years to write *Gone With the Wind*; it was after a two year search that Selznick selected this English player who appeared in *Fire over England* and *A Yank at Oxford* for the leading role.

"She's in mourning," the bazaar gossips murmured as Scarlett's widow's veil floated energetically about here and there. "She can't dance."

But—when Rhett paid $150 in gold for the privilege of leading the reel, and selected Scarlett as his partner, she danced airily out on the floor. Atlanta shuddered in horror.

■ Heigh ho. Neither Scarlett nor anyone else danced in Atlanta when subsequent scenes arrived. For war came to Atlanta, to the city built on the forty acres behind the Selznick Studio. From old photographs, a dozen street of the town were reconstructed with a painstaking fidelity to detail. Even the street signs were faithfully reproduced. And, with an equally painstaking fidelity to detail, the dozen streets were promptly ravaged by shot and by fire. Among other items, the entire Atlanta railroad yards were copied. Copied to be burned down.

■ To show you the thought expended on little things: In the very midst of the burning of Atlanta, a soft, quiet voice observed amid the roar and crackle: "Not 'My heart is sad,' but 'Mah haht' . . ."

In the corner sat Susan Myrick of Macon, Ga., the "Southern-Accent" coach. She was gazing with intensity at a pupil, a bit player, who wanted to say into the sound track something about his Midwestern hearrrrt. It appears that the English, who don't care for the letter "r" anyway, have caught the Southern accent more quickly than some of the American players.

■ But, laws a-massy! What are we-all doin' out yere on the back lot when we don lef' Massa Leslie Howa'd watchin' the "bazaah" set in which he tooken no part because the plot has him off yander somewhe'es a-fightin' the da— that is, the Yankees. Oh, yoo hoo, Massa Leslie! Oh, there y'all y'are—we mean, is. There y'is, suh, and we was speakin' 'bout Missy Scahlett . . .

"I was saying," Howard resumed, "that women admire Scarlett more than men do. Partly because in a business contest with men she could hold her own, she could make her way independently, scattering opposition.

"Not that a man likes a woman to be a mouse," he added hastily. "He likes her to have some spirit. Even a flare of temper now and then, within reason. This renders her more interesting. A man doesn't know exactly what to expect, his interest is held.

"And it's true that if other men are attracted to a woman, this both flatters a man's judgment and keeps him a little uncertain of her. He thinks to himself that somebody *might* take her away from him, he'd better be on his guard, he'd better be attentive.

"But he doesn't want to be completely uncertain, as a man would be of Scarlett. A man never could be sure of her. I said she'd get what she wanted, although she destroyed herself doing it. Well, she'd get it although she destroyed everybody else in the process, too, and that is an alarming prospect! She was as undisciplined as some of our modern sub-debs."

He smiled, as if nothing could be more undisciplined than certain of those.

"I've known women who were like Scarlett," he added in a serious tone, "self-centered, ambitious. Women who, like her —perhaps, in a way, she was forced to do it by circumstances—put themselves first, other people second. I know a woman who is losing her husband because of that very quality, and I don't believe she understands what has happened.

"Naturally, Scarlett had good traits— who hasn't? And doubtless she emphasized her aggressive traits because, as I said before, she was a modern girl in an old-fashioned setting, and whatever she did required more boldness — more real courage, too—than it would require today. But do you realize that today Scarlett wouldn't make much of an impression? I mean, her independence, not her looks.

"Independent? Headstrong? Self-centered? Hard? Granted. But put Scarlett among some of the girls you meet nowadays in London and Paris and New York, and she'd have so much competition . . . !"

Why, Massa Howa'd!

"I didn't say all of them," he retorted, "but I did say some!"

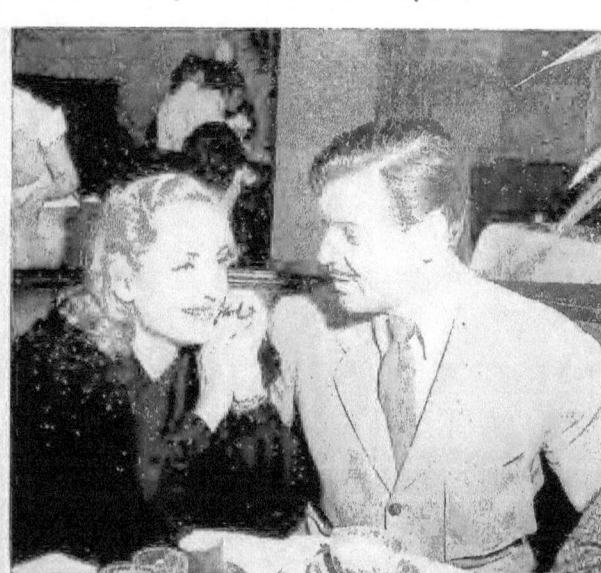

Dining out at the Brown Derby are Ma and Pa Gable. Clark has just completed *Comrade X* with Hedy Lamarr. Carole is working on RKO's *Mr. and Mrs. Smith*

Vivien Leigh, as Scarlett Clark Gable, as Rhett Butler

Win Lovely Prizes

"Gone With The Wind" Contest

Here is your chance to win enchanting prizes. Clip that coupon today, and send in your entry

GRAND PRIZE, complete "Scarlett" set

FIRST PRIZE, "Tara" bracelet, necklace

When Ricarde, famous jewelry designer, saw the lovely old brooches, necklaces, ear-bobs, rings and bracelets that had been collected for Vivien Leigh and Olivia de Havilland and the rest of the cast to wear in *Gone With the Wind*, he said "Ah!" just as you will when you see them on the screen.

Before the Civil War, the South was wealthy, and some of the loveliest jewelry ever seen in America was worn by the great ladies of Georgia. When David O. Selznick was preparing to film *Gone With the Wind*, he borrowed priceless heirlooms. They must be returned to museums or to the families which graciously helped by loaning them, but Ricarde, in the meantime, has made modern versions of the lovely jewels you will see in the film.

The glorious "Scarlett" set, offered as grand prize in this contest, is one of the handsomest awards offered in a HOLLYWOOD Magazine contest. Ricarde has made really distinguished costume jewelry from the lovely old patterns, so read the rules, fill out the coupon on page 16, and try for YOUR prize today.

HOW TO ENTER

The contest, itself, is fun.
[Continued on page 16]

Ricarde of Hollywood, adapter of the heirloom jewelry worn in *Gone With the Wind*

SECOND PRIZE "Melanie" bracelet and earrings

THIRD PRIZE "Robillard" brooch and earrings

FIFTH PRIZES "Robillard" ring

FOURTH PRIZES "Suellen" brooch

Gable—Lion Tamer

What happens when a matinee idol starts after a mountain lion with a rope and a forked stick

By THOMAS RILEY

Ever climb a tree and find yourself face to face with an indignant lion?

If you haven't, you're missing something, Clark Gable claims. He ought to know, he's done it so often he's chummy with most of the lions in Arizona. And that's only the half of it—he captured the lions!

He says it's fun, the best sport he knows. Why? Because "it's good for plenty of laughs . . ."

And he insists he feels safer with the lion than he does with the autograph hunters at a preview. What kind of a beast is this anyway?

Gable calls them cougars, but to most of us in California they're known as mountain-lions. He has nothing but contempt for them, claiming they're shamefully unmanly. "Rabbits are braver than cougars; in fact, a cougar is the big sissy on four legs." And if you listen long enough, and don't happen to know any cougars personally, you'll get the impression that the big cats collapse at the mere glimpse of a man.

Nevertheless, don't start making faces at the next cougar you meet and expect him to faint in his tracks. No, indeed! You might not believe it, after listening to Gable, but this white-livered marauder packs a wallop in each paw that makes Joe Louis look like Aunt Hetty busting an egg. With one swat a cougar can kill a horse or steer. His dental equipment isn't so bad, either, because when he peels back his lips to spit at you (his favorite trick) he exposes a mouthful of teeth that shames Walt Disney's Big Bad Wolf. He weighs around two hundred, and in spite of what Gable says, he's pretty tough when he gets sore. Teddy Roosevelt cites a few instances of men being killed by cougars, and there are plenty of men that have been badly clawed and bitten.

Besides "plenty of laughs," there's another reason Gable shins up Arizona cedars for a few licks at a cougar. He hates them. Cattlemen hate them, too, because cougars have an expensive habit of feeding on livestock. But Gable hates them because they kill deer. "One cougar," he tells you, "kills at least two deer a week. That's over a hundred deer a year for each cougar. I figure in taking ten cougars I've saved a whale of a lot of deer."

It's odd the way he feels about deer. Gable's a dyed-in-the-wool hunter. He has been one ever since he was a boy back in Ohio, bouncing bullets off the neighbor's silo, but, he says, "I think deer ought to be protected. And that goes for moose too." His idea seems to be: mop up on the predatory cougars and grizzlies, but save the deer and moose and elk.

When the urge comes over him to take a whack at a lion in the lion's backyard, Gable throws his rasslin' clothes together and heads for the Kaibab Forest of Arizona. This is a tough country—full of canyons, crevices, sage, cedars—and cougars.

Camp is at the end of the road. In the party, besides Gable, is a professional lion-hunter with a pack of gaunt hounds, and a cowboy to tend horses. The hunting is so gruelling extra horses are required. "Horses don't last long up there," Gable explains, "the country wears them out. I've had my horse belly-deep in snow chasing a cougar."

"We're up before dawn, and man is it cold! By the time we've wrapped ourselves around some hot coffee and biscuits it's getting light, so we saddle up and get going."

The hounds do most of the leg work. As soon as the guide unties them they let out a whoop

Gable—Lion Tamer

and go sailing off looking for a cougar. Every rock is sniffed, every twig and bush. When the pack picks up a scent, the canyons resound with howls and the hunt gets started in earnest.

"Keeping up with the hounds is the hardest part of the whole business," Gable says. "No rider can stay with them. They're out of sight in no time at all and then you've got to follow your ears—and in a country like that, that's something!"

The chase winds into canyons, up mountain sides, across patches of sagebrush and slam-bang into a clump of cedars—then suddenly Gable catches up with the pack. They're sniffing around the carcass of a deer. Gable drops off his horse for a look.

"Usually, it's a cougar kill—and hardly cold," says Gable, his voice getting hard.

"You can figure that a cougar'll stay pretty close to a fresh kill," Gable explains. "His stomach's full and he's probably sunning himself on a rock. Anyway, it doesn't take long to find him. Half hour, maybe. The dogs chase him up a tree. Then the fun begins.

At a safe distance up a cedar the cougar crouches, swishing his long tufted tail and spitting insolently at the dogs. He looks furious. Every time he spits at the hounds he shows some big white teeth.

"He's just kidding," Gable discounts, "inside he's scared silly."

"Are all of them that yellow?"

"All I've met."

"What goes on then?"

"We rope him."

This is extravagant understatement. When Gable says "we rope him," it doesn't mean that they stand on the ground and throw lassos at the cougar. No, nothing so sensible as that. Gable goes up after him!

First he divests himself of all surplus accoutrements such as chaps, spurs, and rifle. For protection he packs along a six-shooter. "But I don't really need that," he adds.

The two implements he uses in capturing the big cat are a long forked stick and a rope. He puts the rope between his teeth, shoves the stick up ahead of him

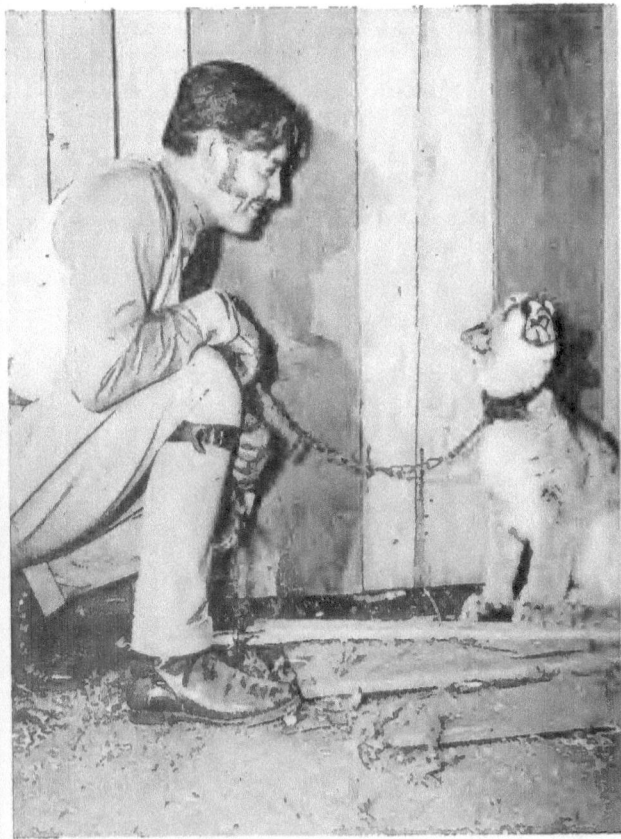

Studio scoffers didn't believe his adventures with mountain lions, so Gable brought back this cub from one of his hunting trips. It is less than half grown

and starts shinning up to have it out with the cougar.

The cougar, who is allergic to men anyway, is upset and backs out on a limb or higher up the tree. Gable follows relentlessly. When the cougar has retreated as far as he can, he makes a stand, snarling impressively, while Gable crawls within a few feet of him.

"Doesn't he show any fight even then?" I asked.

"Well," Gable confesses, "he's a little better. He might even take a poke at you."

"If he did land one, what then?"

"He'd slap you out of the tree, I suppose. That doesn't often happen."

"Has he let you have it yet?"

"Not yet. You see, if you use the stick right when you're roping him . . ."

■ The actual roping would give the ordinary person the jitters, though Gable claims that once you get the hang of it there's nothing to it. All you have to keep in mind is that the cougar is just twice as scared as you are, so he says.

With the cougar cringing at the end of a limb, Gable gets ready for the capture. He makes a noose in his lariat and dangles it on the forked end of the long stick. Then he extends the noose toward the cougar, trying to slip it over his head. The cougar usually thinks this is carrying things too far. He takes a swipe at the rope and sends it flying.

"He's smart that way," Gable admits. "Sometimes he doesn't take to it at all."

"Does the cougar stay put all this time?"

"Not always. Sometimes he jumps."

"Jumps? Where?"

Gable chuckled. "Usually to the ground. If he does, the dogs take a few nips out of him, and chase him up another tree. Then we do it all over again."

This may go on for some time, or until Gable can convince the cougar that he might just as well give up and let himself be roped. Once the noose is around the cougar's neck, Gable lets out a whoop, jerks the rope up tight, and drops the other end to the men on the ground. They yank the cougar off his porch so that he dangles from a limb.

"From that point on is a fine time to get your face clawed apart," Gable admits. "Hanging that way, he has a chance to get all four paws operating, and it's up to us to hog-tie him. That means throwing a half-hitch around each paw."

■ Muzzling the cougar has its moments too. Those teeth of his would make hamburger of your leg if they had the chance, so something has to be done about them too. Gable thrusts a thick piece of wood at the cougar's face and the cougar, thinking it's Gable, joyfully clamps his teeth into it. Before he can sense the swindle, Gable shoves the stick further back in his mouth, then wraps wire around the jaws. It's very simple if you don't miss.

Gable hasn't missed yet and he's gagged ten of the toothy kitties, not including a cougar and it was up to Gable to get him out before he was knocked out. When Gable reached the hound the cougar attacked. Instead of backing away, he came towards them, snarling. "For a while it was hard to tell what was going to happen. I thought he'd slap our ears down, but the guide shied a rock just then, and gave us a chance to drop to the ground."

And the time the ground-crew got overambitious and yanked the cougar clear out of the tree instead of over a limb isn't so bad either. In dodging the cougar, mama cougar and her two little cougarettes. These children are a tale in themselves.

Gable, it seems, had been absorbing a lot of ribbing because of this lion-roping stunt of his. The M-G-M boys intimated that Gable talked very heroically, but that he never had anything to show for it. That grew to be very unfunny after a while, so, when the next cougar he rassled turned out to be a female with a family of two, he decided to bring the kittens back to Hollywood as proof. Before he left Arizona one of the kittens chawed his way through his tether and blew. The other remained and Gable was able to display him around the lot. The kitten, though serviceable as proof, developed into a problem. For the tawny little fellow grew quickly, and presently came to look something like the thing that chased Uncle Matt the night he drank the wood alcohol. He had long white teeth, and he began taking amiable but murderous swipes at anyone who went near. So Gable tried to palm him off. He offered him gratis to the zoo, but the zoo had had a cougar once and said that one was more than enough. "The last I heard," says Gable, chuckling like a man who has just set fire to his mother-in-law, "the studio had it under contract."

■ When queried about narrow escapes he smiles and says "No, nothing important." But there was the time one of the hounds went right up a tree after a Gable lost his footing and fell. Both he and the cougar hit the ground at the same time and almost in the same place. The cougar was too taken up with the rope around his neck to swat Gable, and Gable didn't pause to press the point—he left fast.

"You can see," Gable says happily, "that the sport's got lots of angles to it. It's a little strenuous for women, of course, but it's one of the best sports in the world. You ought to try it some time."

Me, I'll take a nice hysterical game of checkers, thank you.

He's been miscast, he's been divorced, he's had unwelcome headlines in the press, but after nine years on the screen he's still tops! "HOW DOES GABLE DO IT?" The secret of Clark Gable's amazing success is revealed in an exclusive article in the July MOTION PICTURE Magazine.

In this same issue you'll find a beautiful colored portrait of popular MICKEY ROONEY, wonder boy of the screen. Printed on heavy paper and free of printed matter, this portrait is one you'll want to keep and treasure.

HOW DOES GABLE DO IT?

MOTION PICTURE
10¢ AT ALL NEWSSTANDS

Gable did not kiss

Around the Gable Ranch

Between pictures, the Clark Gables spend their time on their new 20 acre ranch in San Fernando Valley. Farmer Gable is working as hard at harrowing his fields as he did in *Gone With the Wind*. Carole Lombard is resting vigorously after completing *Vigil in the Night*. The horse in the picture in the lower corner is "Sonny," who follows at Gable's heels wherever he goes on the ranch

RING IN THE NEWS

Nineteen-forty brings

DAVID O. SELZNICK'S *production of* MARGARET MITCHELL'S
Story of the Old South

GONE WITH THE WIND

in TECHNICOLOR *starring*

CLARK GABLE
as Rhett Butler

LESLIE HOWARD • OLIVIA De HAVILLAND

and presenting

VIVIEN LEIGH
as Scarlett O'Hara

A SELZNICK INTERNATIONAL PICTURE
Directed by VICTOR FLEMING
Screen Play by SIDNEY HOWARD • Music by Max Steiner
A Metro-Goldwyn-Mayer Release

A MAN AND A WOMAN fleeing nameless terror...through angry seas and the tropics' dangers...yearning for the peace they had never known, the happiness they could find only in each other's arms...You'll remember this star-crowded Metro-Goldwyn-Mayer picture as one of the great emotional experiences of the year!

CLARK GABLE · JOAN CRAWFORD

in Metro-Goldwyn-Mayer's Dramatic Triumph

STRANGE CARGO

with IAN HUNTER
PETER LORRE · PAUL LUKAS
ALBERT DEKKER · J. EDWARD BROMBERG
EDUARDO CIANNELLI

A FRANK BORZAGE *Production*

Screen Play by Lawrence Hazard • Directed by Frank Borzage
Based on the Book "Not Too Narrow, Not Too Deep" by Richard Sale
Produced by Joseph L. Mankiewicz

IMAGINE!
They're all in one picture and it's a sensation!

CLARK GABLE
SPENCER TRACY
CLAUDETTE COLBERT
HEDY LAMARR
in
BOOM TOWN

 Screen Play by John Lee Mahin • Based on a Story by James Edward Grant • Directed by JACK CONWAY • Produced by Sam Zimbalist • *A METRO-GOLDWYN-MAYER PICTURE*

VIVIEN LEIGH—CLARK GABLE

That Wind is here again! Vivien Leigh and Clark Gable in a scene from David O. Selznick's Academy Award winner, *Gone With the Wind*, soon to be nationally released at popular prices.

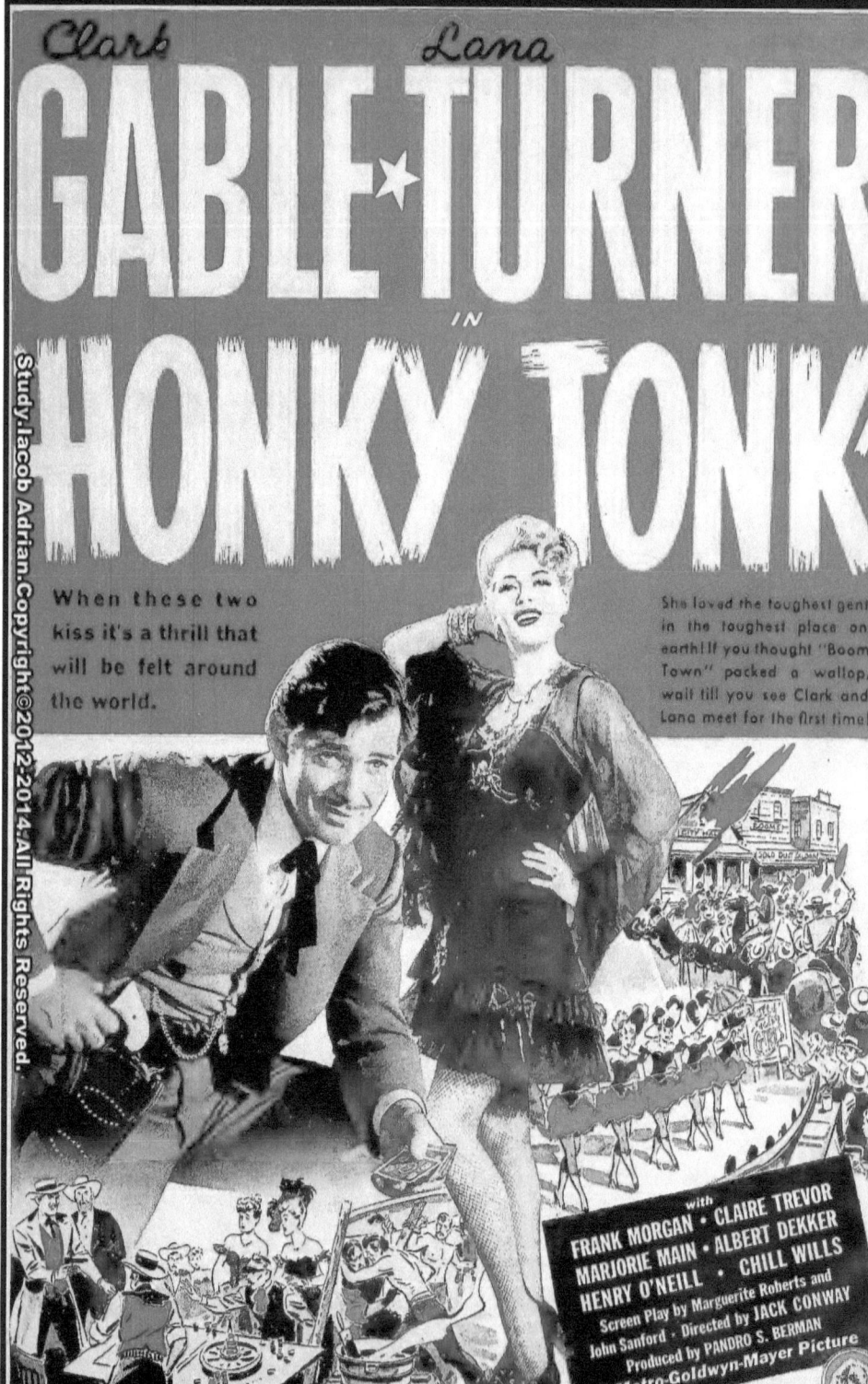

TWENTY COMPLETE STORIES FOR FIVE CENTS

Hollywood

DECEMBER

HOLLYWOOD 5¢

CLARK GABLE

WHY GABLE IS TODAY'S TOPIC FOR GOSSIP

By EDWARD MARTIN

Why Gable is Today's Topic for Gossip

William H. Gable, a plain man from Ohio, had a birthday the other week. His son Clark had given him a little car to use on hunting and fishing expeditions and Gable, Sr., dropped around to the studio to express his thanks. It was only the second time he had ever set foot in a studio.

Clark's director in *Honky Tonk*, Jack Conway, exchanged a few words with the star's father.

"That's quite a boy you raised," he said, trying to draw the old gentleman out.

"He's all right," came the grudging reply.

"One of the nicest things about him is that he's not conceited," Conway went on.

"Hell," said Mr. Gable. "He never had anything to be conceited about."

That opinion coincides exactly with Clark's own opinion of himself. And it's an odd opinion when you consider what Hollywood is whispering about its loftiest star, the man with the fattest contract in movie history.

"High-hat" and "stuck up" are the mildest of the appellations being applied to him by the film colony smart set.

This surprising attitude toward the erstwhile social idol is attributable to Clark's absence this season from the fashionable haunts of the film folk. The race track, the night clubs, the big charity affairs have seen him not. While working at the studio he has spent his spare time at his Encino home. Between pictures he slips away with Carole to little-frequented desert resorts where the telephone and telegraph can not reach him.

Is this being high-hat? Does absence from the gay spots mean that Clark is giving his Hollywood friends the brush-off?

Take it from him direct:

"It's merely a change of pace," he explains. "I've always been nuts about hunting and fishing. This year I'm taking a little bigger dose of them than usual, that's all."

But what about holidays and evenings and the months when hunting and fishing are out of season?

"I'm getting literary," he admits. "You know, the missus is just about the best literary critic in town. She reads every play and book she can get her hands on. I'm learning to be a kind of assistant critic. We don't read selfishly, looking only for vehicles for ourselves. Frequently when we find one we like, Carole recommends it to one of her friends. She's personally responsible for finding about six stories a season."

An additional factor that keeps the Gables out of circulation is Carole's health, which has been none too robust. Sunshine and regular hours are doing wonders for her, and Clark wants to keep in step with her routine.

It's no secret that Clark and Carole are anxious to purchase a large ranch either in Arizona or Nevada. But it is a secret that the ranch, if they find one, may be the scene of their retirement from the screen. Clark and Carole, both veterans of many years before the cameras, are about ready to quit and become plain Mr. and Mrs. Gable. And when they do retire, they don't intend to do it in Hollywood.

It was this concentrated effort to stay out of the spotlight as much as possible that resulted in the heavy barrage of separation rumors, which were consistently denied by both Clark and Carole. The gossip columnists and air commentators have taken turns at both confirming and denying the rift rumors rampant in the Gable household, without so much as bothering to approach either of the parties involved!

When a certain air commentator's report filled the Gables' living room where Clark and Carole were seated before their huge fireplace Gable, the great tough guy of the screen, unable to restrain himself any longer, took his ire out in a solid form by picking up the radio and smashing it against the wall. As soon as the first flash of anger subsided and the Gables had cooled off sufficiently to view the matter coldly and impersonally, they got into their car and drove into town where their public appearance at Ciro's hastily killed the unkind rumor.

Another factor enters strongly into the picture. Both Clark and Carole are crazy about children. It is their hope that outdoor life in restful atmosphere from hectic Hollywood activities will restore Carole's health, and once that vital problem is licked, they will be ready to face the matter of parenthood. They both want their children to grow up in normal, unglamorized conditions like other wholesome, unspoiled American children.

The race track has also been ruled out of Clark and Carole's lives. The race horse Clark used to own has gone on the auction block, along with a score of other luxuries.

These sane and simple reasons are all that lie behind Clark's new "exclusiveness." Anybody who thinks otherwise is entitled to glance over Clark's own estimate of himself and his career. Any doubt about his regularity will be instantly dispelled.

Has Gable gone high-hat? Is he giving his Hollywood friends the brush-off? The film colony is buzzing with speculations about the "changed" Clark Gable. His most recent picture is *Honky Tonk*

Why Gable Is Today's Topic for Gossip

"I landed in Hollywood because I was pushed by cold weather and pulled by Number 7," he recounts in his down-to-earth manner. "There's been a lot of Hollywood baloney about lucky numbers. With me Number 7 isn't a lucky number; it's a Go signal, and I'm not kidding.

"When I was a kid in Cadiz it was my greatest ambition to get on the neighborhood sandlot baseball team. I was a big, ugly rawboned kid and didn't look like material for the Cleveland Indians. But the fellows gave me a tryout. They didn't own a mask so they let me be the catcher, expecting I would get my teeth knocked down my throat. They asked me what position I wanted to bat in and I said seventh, thinking I'd get beaned by the pitcher long before my turn at bat ever arrived. "Well, old 7 gave me the Go signal. That day I hit three homers and got a regular job on the team.

"My first salaried job was in a rubber factory at Akron. I told a few fairy tales about my age and experience and went to work at $7 a day. When my Dad and I teamed up to work in the Oklahoma oil fields I made that same magic salary. In those days seven bucks looked magic to me. I still have a good healthy regard for seven bucks because in the intervening years I was so often without any bucks at all.

"On January 7th I joined up with a repertory company touring the West. I've been trying to be an actor ever since.

"But there was more cold and more Number 7's between me and Hollywood. Our company went broke in Butte, Montana, on February 7th. Also, I personally went broke. Blizzards were in season and I had nothing but a cheesy little topcoat to ward off the wind.

"I went into a barroom to get something to eat off the free lunch table. In Butte it's a hanging offense to enter a cafe without a silver dollar in your kick. Hunger made me eloquent, I guess. Anyway, I jawboned the bartender out of a picnic meal. With a full stomach I felt adventurous again.

"I went down to the railroad station and cuddled up to the pot-bellied stove. On the bulletin board I noticed that Train Number 7, going West, was due.

"'That's for me,' I said, and went out to the freight yard. When Number 7 pulled out of Butte I and five other hoboes were in a nice cool refrigerator car. That train took me to Portland, a regular job in stock, and eventually to the *Last Mile* performance in Los Angeles that landed me in pictures."

Until he made *Honky Tonk* Clark had hardly an uncomfortable moment in California.

"A bad moment came at the end of my new picture. I'm supposed to be a tinhorn gambler, run out of every town in the West. One scene shows me running for a freight train. That touch had a little too much autobiography in it, too."

Is this the guy Hollywood is calling high-hat? If so, Hollywood had better go wash out its mouth with soap. ■

GET YOUR
STAR DOLL
✮ FREE ✮
WITH THE MARCH ISSUE OF
SCREEN LIFE

THIS time it's dashing Clark Gable! With your copy of the big, new SCREEN LIFE you get, absolutely free, a fascinating cut-out doll of Clark Gable, plus five changes of costume in full color.

This entertaining novelty, exclusive with SCREEN LIFE, adds immensely to the pleasure your favorite fan magazine offers, without adding a cent to the cost!

The new SCREEN LIFE is packed from cover to cover with sparkling feature stories and beautiful photographs of your favorite motion picture stars.

You won't want to miss "Tips on Trifles" in which twelve male stars tell what irritates them most about women. You will enjoy this frank, amusing story—and you will profit by it, too.

The complete story of Lucille Ball's helter-skelter elopement with the dashing Desi Arnaz is another outstanding feature in SCREEN LIFE. You'll want all the details of this romantic marriage.

These are only two of the dozens of features that make SCREEN LIFE the smartest and brightest of movie magazines. Get your copy today!

A FAWCETT PUBLICATION

SCREEN LIFE
10¢ AT ALL NEWSSTANDS

All the world grieves at the sudden and tragic death of Carole Lombard, the first Hollywood personality who died in the service of her country. Carole was returning to Hollywood after selling $2,000,000 in Defense Bonds in her native Indiana. This is one of the last pictures taken of the patriotic star before the ill-fated plane plummeted her, her mother, Mrs. Elizabeth Peters, and 19 other passengers to their death. Carole is shown with her devoted husband, Clark Gable, and their very good friend, Jack Benny. The editors of *Hollywood* salute the memory of a truly great person

TWENTY COMPLETE STORIES — NEW PLAYERS AND OLD

HOLLYWOOD

OCTOBER

HOLLYWOOD
5¢

THE FOUR MOST HATED PEOPLE IN HOLLYWOOD

Scenes from
Clark Gable's
Farewell Picture
with Lana Turner
See Page 23

Gable's Farewell Film

Clark Gable has quit the screen for the duration. He is a brave man who feels there is another place for him where he can better serve his country. His enlistment as a private in the machine gun corps of the Air Force proves he is a real patriot without any thought of material gain for himself. His farewell film is ironically entitled *Somewhere I'll Find You*. It is another of those action-filled pictures in which Gable, a war correspondent in the Pacific, falls in love with Lana Turner. These scenes depict some of the exciting moments from the film

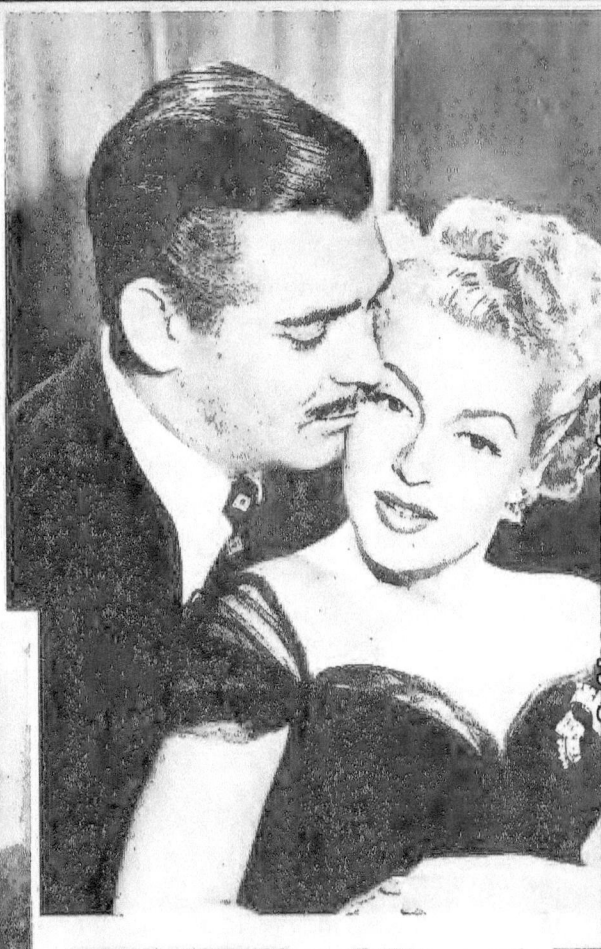

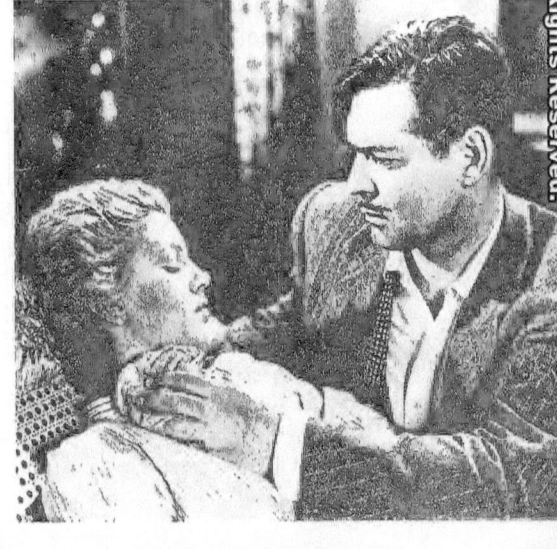

Bibliographic sources :

Hollywood (1934-1943)
Publisher: Hollywood Magazine, inc. ; Fawcett Publications, inc.

The New Movie Magazine 1930 - 1935
Publisher: Tower Magazines, inc.

This documentary study use,
combined in various proportions,
elements from the following categories,
forms and subsets :
- fair use
- documentary
- documentary photography
- feature
- journalism
- arts journalism
- visual journalism
- photojournalism
- celebrity photography
in order to :
- employ material as the object of cultural critique ,
- quote to illustrate an argument or point ,
- use material in historical sequence,
providing independent opinion,
using photos, press articles, advertisements,
opinions of fans etc. ...

www.ingramcontent.com/pod-product-compliance
Lightning Source LLC
Chambersburg PA
CBHW021015180526
45163CB00005B/1960